A POCKE

CARDIFF

A POCKET GUIDE

CARDIFF

JOHN DAVIES

CARDIFF
UNIVERSITY OF WALES PRESS
THE WESTERN MAIL
2002

Published by the University of Wales Press and The Western Mail.

British Library Cataloguing in Publication Data
A catalogue record for this book is available from the British Library

ISBN 0-7083-1730-8

Cover photograph: Andrew Davies/Photolibrary Wales
Cover design by Chris Neale
Typeset by the University of Wales Press
Printed in Great Britain by The Bath Press

I

Ianto

Contents

Preface

I have never been in any doubt that Cardiff is my city. I must have been about three years old at the time of my first visit. We called on an aunt who kept a ships' chandlers in the Hayes. The Glamorganshire Canal lay at the bottom of her garden. I fell in and, although I had been properly christened at Bethlehem, Treorci, I look back at my dip in the canal as my real baptism. Cardiff was the obvious place to seek a university degree and, by changing lodgings every term, it was possible to live in nine of the city's areas. When the opportunity came to pursue research, the history of Cardiff beckoned. Employment took me away from Cardiff but, during my years in Swansea and Aberystwyth, not a month passed without at least one visit to the city. Now freed from the confines of a regular job, I have come back to Cardiff, at least intermittently.

To be invited to write the pocket guide to Cardiff was a great pleasure. In writing it, I have been much indebted to the staff of the University of Wales Press, in particular Ceinwen Jones, Liz Powell, Susan Jenkins, Sandra McAllister and Sue Charles. As always, my greatest debt is to my wife, Janet Mackenzie Davies, who read and reread the typescript, prepared the index and accompanied me on many city perambulations. It is gratifying that all our four children have opted to live in Cardiff.

To dedicate the book to the youngest of them is a special delight.

John Davies
Grangetown
January 2002

Acknowledgements

The author and publishers gratefully acknowledge permission granted for the following illustrations:

Map of Cardiff in 1849 (p. 41), St Mary Street in 1870 (p. 52), Bute West Dock *c.* 1870 (p. 62), the *Terra Nova* (p. 71), Billy the Seal (p. 97), Llandaff Cathedral (p. 100) reproduced by permission of Cardiff Central Library. Pack-horse convoy (p. 5), originally printed in *Cardiff: A History of the City* by William Rees and credited to Cardiff Corporation, also reproduced with the help of Cardiff Central Library.

Winter Smoking Room, Cardiff Castle (colour section p. 7), western façade of Cardiff castle (p. 21) reproduced by permission of Cardiff City Council.

Railway sidings (p. 65), Coal Exchange (p. 70) reproduced by permission of the National Museum of Wales.

Cardiff's Roman forts (p. 12) by permission of Peter Webster.

The northern wall of Cardiff Castle (p. 13), Raeburn's portrait of the second marquess of Bute (p. 39), lion from the Animal Wall (p. 53) reproduced by permission of Cardiff Castle.

Cardiff Castle keep (p. 15), bilingual signs (p. 130), view over Cardiff (colour section p. 1), Pierhead Building (colour section p. 6), Norwegian Church (colour section p. 3), Llandaff Cathedral (colour section p. 2), City Hall and dragon detail (colour section p. 4), Millennium Stadium (colour section p. 6), Castell Coch (colour section p. 8), lighthouse at Roath Park (colour section p. 1) all by permission of Patricia and Charles Aithie, ffotograff.

Greyfriars House (p. 19) Francis Frith collection.

Church Street and St John's Church (p. 23) by permission of Glamorgan Record Office.

Coat-of-arms on the Pierhead Building (p. 72) and barrage (colour section p. 3): David Williams/Photolibrary Wales. Castle Arcade (colour section p. 2) and Golden Cross (colour section p. 5): Steve Benbow/Photolibrary Wales. Queen Street (colour section p. 7): Chris Colclough/Photolibrary Wales.

Map of Tiger Bay (p. 74) by permission of Neil Sinclair.

Drawing of Cathays Library (p. 93) by permission of Cathays Library. Photograph by Bryan Turnbull.

Plasturton Gardens (p. 95) from a postcard in the collection of the late Fred Jones, by permission of Colin Jones.

Main building, University of Wales, Cardiff (p. 114); civic centre (p. 131) by permission of University of Wales, Cardiff.

Former Welsh Office (p. 124) by permission of the National Assembly for Wales.

Photograph of steelworks (p. 86) from *The City and Port of Cardiff* ('Cardiff Blue Book') kindly lent by B. J. Lee.

New maps and graphs were drawn by Anna Ratcliffe.

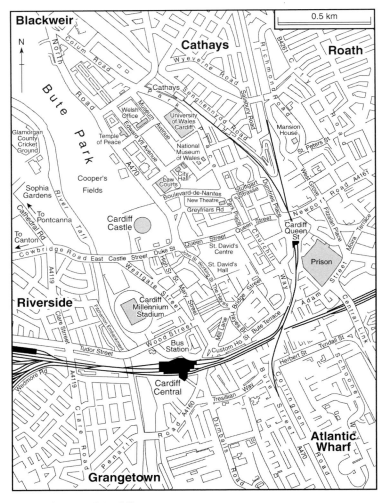

Present-day central Cardiff.

1 The View from on High

The place to start is the summit of the ridge of Caerffili Mountain. The ridge is also known as Cefn Cibwr and represents a boundary of great antiquity. To the north lies the commote of Senghennydd Is Caeach, the middle commote of the *cantref* or hundred of Senghennydd. To the south lies the *cantref*'s southernmost commote, Cibwr, the land between the lower Taff and the lower Rhymni, a commote in which Cardiff was once the main settlement, but which has by now been totally taken over by the city and its suburbs.

Looking southwards from Cefn Cibwr, one can see an extensive panorama of the whole of the county and borough of Cardiff. The first impression is that this is a flat city. Admittedly, there is a small upthrust at Pen-y-lan where Lower Palaeozoic rock, the oldest geological formation in Glamorgan, rises to some sixty metres, and boundary changes have brought Cefn Cibwr, averaging some 250 metres above sea level, and the 300-metre Mynydd y Garth within the city limits. Yet little in the panorama visible from Cefn Cibwr rises much above twenty metres. The view is that of the flat capital of a country which has defined itself in terms of its mountains. It thus contrasts markedly with its peers, the capitals of others of the smaller nations of Europe, the Basque Country's Gasteiz (Vitoria) with its upper town, for example, and Slovakia's Bratislava and Slovenia's Ljubljana, each with its castle hill. But that is probably how it should be, for were Cardiff not situated on a flat estuary, it would never have become the capital of Wales.

Not only is Cardiff's site undisturbed by intrusive thrusts, but so also is the silhouette of its buildings. The city is not a slimmed-down version of Manhattan or Toronto. Cardiff's highest building is the 25-storey Pearl Assurance building, which since 1970 has glared down upon Cathays Park, a mere pygmy compared with the 125 storeys of Kuala Lumpur's Petrones Towers. In the centre of the city, older and more gracious projections are still clearly visible, with the fifteenth-century tower of St John's standing proud, slightly overtopped by the

1

clock tower of the castle, which in turn is overtopped – a deliberate civic ploy, this – by the splendid tower of the City Hall. The suburbs consist in the main of low-rise terraced and semi-detached houses, for this is no Glasgow, where massive blocks of flats have mushroomed everywhere.

The panorama is also that of a very green city. Below Travellers' Rest, the inn on Caerffili Mountain, are the slopes of Cefn Cibwr, with Coed y Wenallt and Greenmeadow Wood to the right and Parc Cefn Onn and Cefnmabli Wood to the left. The leafy expanse of Cathays Cemetery is clearly visible, as is the hollow containing Roath Brook edged round by Roath Park. Above all, there is the snaking series of parks following the course of the River Taff – Coopers Fields, Bute Park, Blackweir, Pontcanna Fields, Llandaff Fields, Hailey Park and on to Garth Wood and Fforest Fawr around Castell Coch – providing Cardiff with a green heart unrivalled by any other British city.

From the summit of Cefn Cibwr, a low roar can be heard. It is the noise of the traffic on the M4 which gashes its way through the landscape, hugging the 85-metre contour line at the foot of the ridge. Completed in the 1970s, it offered release from the congested A48 which once carried the traffic traversing Glamorgan through the very heart of Cardiff. From Cefn Cibwr, one can just about see the A48 wending its way through St Mellons and Rumney and emerging the other side of Cardiff to climb up the Tumbledown on its way to Cowbridge. It follows almost exactly the Roman road that linked Caerleon to Carmarthen, the road which provided the impetus for the initial establishment of a settlement at Cardiff. That settlement was the Roman fort first built at Cardiff in about AD 55, and was located at the point where the road was carried across the River Taff. The fort (*caer*) and the river (Taff) gave the place its name. The English form has ancient Welsh roots, for the *diff* element reflects the genitive form of early Welsh, a form which had been lost by about AD 700. (*Caerdydd*, the modern Welsh form, is not attested until the 1550s.)

While its location astride the main road across the lowlands of southern Wales was the key to the establishment of the original settlement at Cardiff, fundamental to the history of that settlement is another aspect of its location. Looking southwards from Cefn Cibwr, a dim blue outline can be seen, floating on the

2

Flat Holm

Located eight kilometres south-south-east of the Taff estuary, the island lies within the community of Butetown and has been part of Cardiff since the foundation of the borough. It is the southernmost place in Wales; the boundary line between Wales and England runs between it and Steep Holm, the island five kilometres to its south. It is 550 metres from north to south and 475 metres from east to west. Excavations have yielded evidence of an early medieval cemetery, possibly that of a hermitage traditionally associated with St Cadog.

The island's Welsh name is usually considered to be Ynys Echni. Yet, according to Caradog of Llancarfan (fl. 1135), Echni 'lies over against England', whereas Ronech 'is nearer to Wales', suggesting that Echni was originally Steep Holm and Ronech Flat Holm. To the Anglo-Saxons, the island was Bradan Relice; the name Flat Holm is considered to be of Scandinavian origin.

It was long a haunt of smugglers, and its chief product was rabbits. By the early nineteenth century, there was one farm on the island, its tenant paying the landlord, the marquess of Bute, an annual rent of £50. A lighthouse was erected in 1738; reconstructed in 1819, it is 28 metres high. Until 1988, it was manned by three keepers, but is now fully automatic. From 1884 to 1937, Flat Holm was the site of an isolation hospital for foreign sailors. In the 1860s, fear of French invasion led to the fortifying of the island and the building of a barracks. During the Second World War, Flat Holm underwent major militarization and was garrisoned by several hundred soldiers.

The island is famous in the history of radio, for on 13 May 1897 Guglielmo Marconi transmitted the world's first wireless messages across water from Lavernock Point to a 34-metre mast on Flat Holm, messages of mind-boggling banality.

In 1972, Flat Holm was declared to be a site of special scientific interest. It is now a nature reserve – a tribute to the importance of its colonies of seabirds and its fascinating flora.

horizon, some thirty kilometres away. It is the shore of Somerset between Clevedon and Burnham-on-Sea. More clear – for it is only eight kilometres from the mouth of the Taff – is the island of Flat Holm. Flat Holm is perhaps the most intriguing part of Cardiff, for it gives the city the distinction of being one of the rare British county boroughs to have an almost secret island within its boundaries. (It is accessible on occasion in the summer – from Barry.) Between Flat Holm and the mouth of the Taff lie Cardiff Roads, a stretch of water sheltered from the prevailing wind by Penarth Head. A hundred years ago, the most striking feature of the view from Cefn Cibwr would have been the Roads, thick with ships waiting their turn to enter the Bute Docks. By now, following the erection of the barrage, Cardiff has turned its back on salt water. Yet, without the sea and access to it, Cardiff would never have been anything more than a huddle of houses around a bridgehead on the road to Cowbridge.

But access to the sea was not in itself enough to ensure the prosperity of Cardiff. There had to be goods to convey. Initially, Cardiff's sea-borne trade consisted of the agricultural surplus of the Vale of Glamorgan, a trade it shared with Aberthaw and other creeks of the Vale's shoreline. To the west, the view from Cefn Cibwr includes some of the fertile fields of the Vale. A keen-eyed observer two hundred and fifty years ago would have been able to discern the carts coming down the Tumbledown carrying grain, butter and cheese from the farms of Bonvilston and St Nicholas to the Taffside quay. There, the produce would have been loaded on to the small ships which wended their way down the four kilometres of the serpentine Taff to the open sea, sailing in the main for the great emporium of the west, the port of Bristol with its Welsh Back along the River Avon.

Two hundred and fifty years ago, an observer would also have seen the beginnings of another trade, for Cefn Cibwr offers a view of the track from Merthyr through Caerffili to Cardiff. In the mid-eighteenth century, that track was traversed by horses and mules strapped with panniers weighed down by the pig iron of the Cyfarthfa and Dowlais iron companies. In the 1770s, however, the track was superseded by a road along the Taff Valley through the Tongwynlais Gorge, a gorge which would eventually accommodate a road (the A470), a canal and four railway lines, as well as the river itself. Down through the gorge

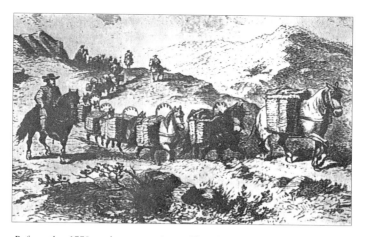

Before the 1770s, when a road capable of being used by wagons was constructed, iron and coal were transported to Cardiff in panniers borne by horses or mules. Horses such as those in the picture each conveyed about a hundred kilograms (two hundredweights) along a track from Merthyr Tydfil to Cardiff via Gelligaer and Caerffili.

poured the mineral riches of the basin of the Taff – initially the pig iron of Merthyr Tydfil and then the world's finest steam coal, mined in the valleys of the Taff and the Cynon and, above all, in the valley of the Rhondda.

It was not only the Taff basin which poured its wealth into Cardiff. Some two kilometres eastwards of Travellers' Rest, imaginative walkers can hear, or choose to believe they hear, a rumble beneath their feet. It is the noise of a train travelling through the depths of Cefn Cibwr along the line of the Rhymni Railway. The railway was constructed in the early 1850s and was provided in 1871 with a tunnel between Cefn Onn and Coed Parc-y-Fan. It delivered to Cardiff much of the coal trade of western Monmouthshire. That Cardiff should have captured the trade of the catchment area of its own river – the Taff – along with the even richer trade of the Taff's tributaries – the Cynon and the Rhondda – was natural enough. To purloin the trade of the Rhymni Valley demanded special stratagems, for the Rhymni trade, as a Monmouthshire industrialist put it in 1825,

5

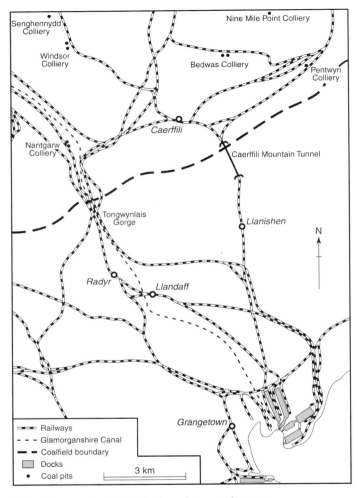

The railways serving Cardiff by the early twentieth century.

6

was 'destined by nature for Newport'. It was a purloining central to the emergence of Cardiff as the pre-eminent port of the south Wales coalfield. The stratagems were those of the Bute estate – of which more, much more, anon – whose officials sponsored the Rhymni Railway, gave it favoured terms at the Bute Docks and made use of the marquess of Bute's power as a major landowner in the Rhymni Valley to insist that the holders of his mineral leases shipped their coal at his docks. By the 1890s, a third of Cardiff's coal exports was conveyed by the Rhymni Railway. Had those exports gone to Newport, Newport rather than Cardiff could have won the race to become the largest urban centre in Wales – or, more probably, Swansea could have emerged supreme by sneaking in between the two.

While the view to the south of Cefn Cibwr embraces the plain of Cibwr, the gentle undulating fringes of the Vale of Glamorgan, the flat Gwynllŵg (Wentloog) Levels and the horizontal surface of the Severn Sea, the view to the north offers an altogether more altitudinous prospect. It provides a panorama of the eastern end of an oval plateau, incised by deep valleys and crowned on the horizon by the strong profiles of the Brecon Beacons. Anyone standing here a hundred years ago would have seen the winding gear of at least a dozen collieries, all producing the coal which ensured the prosperity of Cardiff and its docks. No winding gear is visible now. As a result of the close-down of the coal industry, the relationship between Cardiff and the communities to its north has been transformed. Once, Cardiff was dependent upon those communities, for they produced the lifeblood of its trade. Now, those communities are dependent upon Cardiff as their inhabitants seek employment in the city's burgeoning service industries. In the twenty-first century, it is proximity to the city, not proximity to rich coal seams, which determines the prosperity or otherwise of the communities of the south Wales coalfield.

Westwards from the car park on the summit of Cefn Cibwr, a path leads to Craig yr Allt above Tongwynlais. There, one can look down on a Gothic extravaganza more splendid than anything gracing the banks of the Rhine. It is Castell Coch, which first came into being in about 1095 as a motte-and-bailey castle, one of several such castles built by the Norman invaders to protect Cibwr's northern frontier. It was rebuilt in stone in the

late thirteenth century and was reconstituted with great panache to the plans of William Burges in the 1870s. Castell Coch is symbolic of the many ambiguities of Cardiff's relationship with the rest of Wales. To its eleventh-century builders, it was a bastion of alien power. To the Clare family, who commissioned its thirteenth-century rebuilding, its purpose was to ensure that Cardiff and the lordship of which it was the centre should not become subject to a native Welsh dynasty.

Yet, an intriguing comment in the writings of Rice Merrick, the sixteenth-century antiquary of Cotrel near St Nicholas, noted that the 'old castle . . . called Castell Coch [is] supposed to be builded by Ifor Petit, a gentleman . . . who . . . took William, lord of Glamorgan'. William was William FitzRobert, earl of Gloucester and lord of Cardiff and Glamorgan from 1147 to 1183, who, according to Giraldus Cambrensis, was captured in 1158 by Ifor Bach, lord of Senghennydd. Ifor kept William a prisoner until all the lands the earl had unjustly seized had been restored to him. The episode is indicative of the instability of the frontier between those parts of Glamorgan under native rule and those under the rule of the incoming conquerors. It could well be that in the 1150s Castell Coch was a power base, not of the lords of Cardiff Castle, but of their opponents, the Welsh lords of upland Glamorgan. The Ifor Bach story was long remembered. In the 1870s, John Batchelor, the most determined opponent of the then lord of Cardiff Castle, the third marquess of Bute, presented Cardiff Corporation with a painting of the abduction of William FitzRobert. A hundred years later, Ifor Bach was chosen as the name of the Welsh-language club established within a stone's throw of the portcullis of Cardiff Castle.

The ambiguities of Castell Coch are also relevant to a fascinating structure erected on Cefn Cibwr itself. That is Castell Morgraig, situated in a cluster of trees adjoining Travellers' Rest. The ruins are in a parlous condition and, if present neglect continues, this fascinating site will soon be incapable of yielding any of its secrets. The fascination arises from the debate over whether the castle was built by the Clares to defend Cibwr against the independent Welsh rulers to the north, or by those rulers to defend Senghennydd against the Clares. Its construction is more archaic than that of undoubted Clare castles. It lies within Senghennydd Is Caeach and seems to be

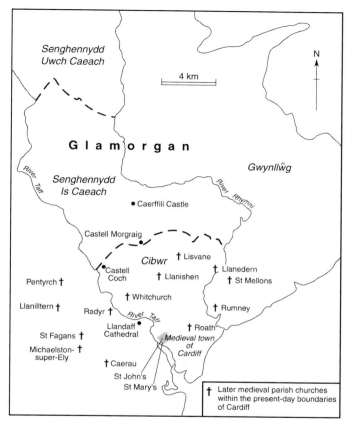

The medieval setting of the commote of Cibwr.

aligned to provide a view southward. These factors suggest that
it was a Welsh castle, perhaps built around 1265 by Gruffydd ap
Rhys, and its unfinished state may be an indication that
Gruffydd had to abandon it when Senghennydd was seized by
Gilbert de Clare in 1267. On the other hand, some of the dressed
stone came from the coast of Glamorgan, where the Clares
would hardly have permitted a potential enemy to quarry
building material. Scholarly opinion now seems to favour the

Clares as the castle's builders, but the debate is further evidence of the ambiguities in the relationship between Cardiff and its hinterland.

As strongholds, Castell Coch and Castell Morgraig were mere gazebos compared with the greatest of the fortresses of the Clare family. That is Caerffili Castle, built in the 1270s and third in size only to Windsor and Dover among the castles of Britain. From Cefn Cibwr, Caerffili Castle is clearly visible, the rather dull Pennant sandstone of which it is built offering a dreary contrast with the cheerful reddish limestone used at Castell Coch – the Red Castle. The extent and elaborate defences of Caerffili Castle are proof of the threat posed to the power of the Clare family by the state-building activities of Llywelyn ap Gruffudd, prince of Wales. North of Cefn Cibwr lay lands ruled by what remained of the princely houses of Glamorgan and, in those lands, rulers and ruled felt a natural affinity with the ambitions of Llywelyn. Caerffili Castle offers impressive evidence of the power and appeal of a resurgent Wales and of a perceived need to protect Cardiff from that resurgence. That Cardiff is now the capital of a resurgent Wales and the seat of most of the country's national institutions suggests a historical reconciliation of rich significance.

2 The Old Town

Searchers for the origins of Cardiff should start in an underground gallery walled by courses of stone laid down some seventeen and a half centuries ago. Looking at them involves making one's way through the core of the southern wall of Cardiff's Roman fort. The gallery is a portion of what remains of the fourth fort to be built on the site. The first, and the largest, made of earth and timber, was erected in about AD 55, when the Second Legion of the Roman army pushed through the lands of the valiant Silurians to plant a bastion of their power on the banks of the Taff. Twenty years later, it was replaced by a smaller fort which, after some fifty years, was replaced by a yet smaller one. The last of the series, that built in about AD 280, is considered to indicate new priorities for the Empire's defences. Cardiff's third-century fort was built in stone. It was the most elaborate structure to be erected in Wales during that century and reflected the need for a base for naval patrols dealing with piracy in the Severn Sea and raids upon its coastal settlements.

Cardiff's Roman fort was probably abandoned in the 380s, but enough of it remained, seven centuries later, for the Norman invaders to consider that its walls offered additional protection to the motte and bailey castle they built within it. The mound upon which the motte was erected may well have been raised at the command of William the Conqueror, who passed through Cardiff in 1081 on his way to St David's. The stone keep surmounting it was probably commissioned in the 1130s by William's grandson, Robert, earl of Gloucester. Under subsequent lords of Cardiff, further buildings were erected along the south and west walls. The Roman fortifications became increasingly ruinous until, sixteen centuries after their erection, latterday lords of Cardiff, the third and fourth marquesses of Bute, decided to reconstruct them.

The reconstructed fort is best seen by leaving the castle and walking along Castle Street and Duke Street. The footings of the Roman fort are clearly visible, and are distinguished from the reconstruction work by a band of pink Radyr stone. A view of the

11

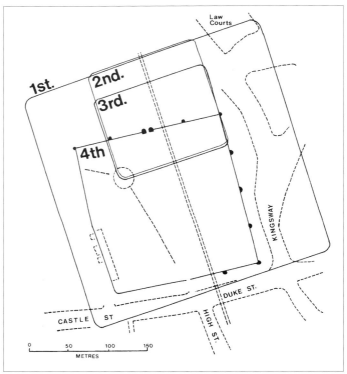

Suggested outline of the curtain walls of Cardiff's Roman forts. The earliest three were of earth and timber, the first erected in about AD 55, the second in about AD 75 and the third in about AD 125. The fourth, built in stone, dates from about AD 280, and occupied the site of the present-day castle.

eastern wall involves walking up Kingsway and, from there, to the north wall where the reconstruction is at its most convincing. Here, perhaps more than anywhere else in Europe, one can appreciate the visual impact of a Roman fort. Admittedly, the walls are up to twice as high as they would have been originally, perhaps on the analogy of the fort at Richborough in Kent, but more probably because the marquesses wanted to have walls high enough completely to shut off the castle from the world.

12

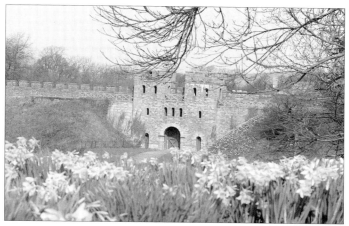

The gate in the northern curtain wall of Cardiff Castle, viewed from the south. The site of the original Roman gate was excavated in 1899, and the building of the reconstruction was undertaken over the following twenty-five years. The layout draws upon excavated evidence and the superstructure is based upon analogy with other sites.

Through groves of magnolias, a path leads to the banks of the Taff where once stood the bridge which carried the Roman road westwards to Carmarthen. During the Roman occupation, an extensive civilian settlement grew up east of the river and south of the fort. That was the *vicus*, a township which came into being to serve the needs of the garrison and to exploit the trading potential of a fortified bridgehead. Nothing of the *vicus* is now visible, but excavations at Castle Street, Duke Street and High Street have revealed the foundations of a considerable number of buildings and much evidence of iron-working.

Apart from a Roman villa at Caerau, the fort, the *vicus* and the bridge are the only evidence of settlement at Cardiff during the early centuries of the first Christian millennium. What happened there in the later centuries of that millennium is veiled in obscurity. According to Geoffrey of Monmouth, writing in the 1130s, Cardiff provided the stage for some episodes in the life of King Arthur, who is presumed – if he ever existed – to have died in about 515. It is unlikely that there is any substance to the stories, and Geoffrey's

13

motive in recording them was probably his desire to flatter his patron, Robert of Gloucester, lord of Cardiff. The meagre evidence available indicates that, from the fifth to the eleventh century, Cardiff lay within the kingdom of Glywysing, the land between the Tawe and the Usk. During the reign of Morgan ab Athrwys (d. *c.* 665), or perhaps during that of Morgan ab Owain (d. 974), Glywysing was linked with the land of Gwent thus creating the kingdom of Morgannwg or Gwlad Morgan (Glamorgan). The seat of the lord of Glywysing may have been at Dinas Powys, six kilometres south-west of Cardiff, where a fortlet, occupied in the fifth and sixth centuries, has been extensively excavated.

Glywysing was a Christian kingdom perhaps from its very beginnings. If *Liber Landavensis*, a collection of charters compiled in about 1130, is to believed, the seat of its bishop had been at Llandaff since the age of the fifth-century saint, Dyfrig. *Liber Landavensis* certainly claims too much, but a tenth-century inscribed stone found at Llandaff suggests that, at that time, there was within the present boundaries of Cardiff an ecclesiastical centre of significance and one which was perhaps already the seat of a bishop.

But for that stone, and inscribed stones at Flat Holm, St Fagans and Llanilltern, there is nothing within those boundaries associated with the period between the end of the Roman Empire and the coming of the Normans. Thus, searchers for the history of Cardiff must jump at least half a millennium in their perambulations and take them up again by returning to the castle. In its centre lies the mound built in the late eleventh century and held until his death in 1107 by Robert Fitz Hammo, who in the 1090s wrested control of the lowlands of Glamorgan from their Welsh king, Iestyn ap Gwrgant, thus creating the marcher lordship of Glamorgan. The motte was originally crowned by a wooden turret in which Fitz Hammo's son-in-law, Robert of Gloucester, held his uncle, Robert, duke of Normandy, as a prisoner from 1126 until the duke's death in 1134. That was replaced probably in the late 1130s by a twelve-sided stone shell keep, an innovative building in its day. It is worth the climb, in order to enjoy the view and to look down at the walls scaled by Ifor Bach in his daring enterprise. A further Welsh incursion occurred in the early 1180s, when much of the castle's dependent borough was burned. In the following century, the Clare family commissioned major

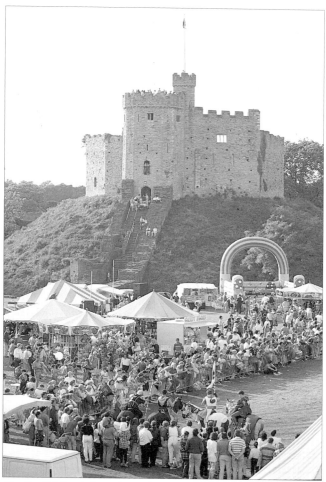

The Cardiff Castle keep. It stands on a motte raised in the late eleventh century. The keep probably dates from the 1130s and is rich in arrow slits. A massive forebuilding extending from the keep was demolished by 'Capability' Brown in the 1770s. The photograph was taken during a summer 'open day' when the castle was host to a jousting tournament and children's fair.

works. These included the Black Tower, which powerfully strengthened the fortifications of the main gate, and a massive wall between the castle's inner and outer ward, a reflection of the need for defence against the campaigns of Llywelyn ap Gruffudd. In addition, there was the rebuilding of the great hall in which the masterful Gilbert de Clare, the Red Earl, lord of Cardiff from 1263 to 1295, greeted his father-in-law, Edward I, in 1284 with the pomp appropriate to a fellow sovereign rather than a subject.

By the 1280s, the decade which saw the collapse of Llywelyn ap Gruffudd's dream of an autonomous Welsh principality, Cardiff was approaching its medieval apogee. It had 423 burgages or urban plots, more than were recorded in any other borough in Wales – Haverfordwest, with 360 burgages, was the runner-up. That Cardiff, in the High Middle Ages, should have been the largest town in Wales was wholly appropriate for, as capital of Glamorgan, it was the chief town of the largest and richest of the lordships of the March of Wales. Assuming that there was a dwelling on each burgage, and that a household consisted on average of five people – assumptions which may be unwarranted, admittedly – that would mean that Cardiff had over two thousand inhabitants. By the beginning of the fourteenth century, the town had been provided with stone walls which replaced the embankment and palisades that had previously surrounded it. The walls would remain standing for hundreds of years – indeed, the last substantial part of them was not pulled down until the 1850s.

A feel for the size of the medieval borough can be gained by perambulating the site of the walls. The perambulation should start at the west gate reconstructed in 1921 near the south-western corner of the castle. From there to the north or Senghennydd gate at the bottom of Kingsway is only a matter of walking a few hundred metres, a walk which passes the only surviving portion of the wall – a lump of stone adjoining the castle's south-eastern corner. The wall continued behind what is now the north side of Queen Street and then turned south. At the west end of Queen Street, the outline of the east or Crokerton gate can be seen, marked out by modern brickwork. From the east gate, the wall ran through the present day St David's Centre, which has a passageway called Town Wall. It then continued along what is now Mill Lane and on to the bottom

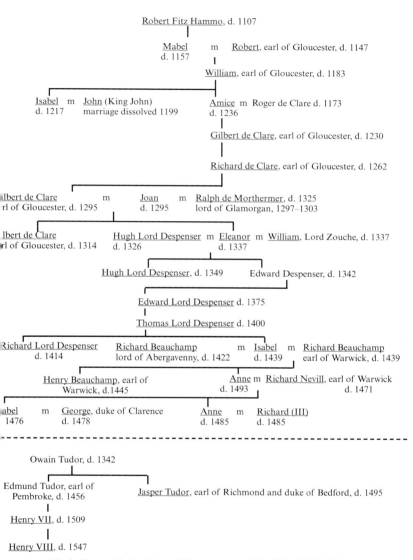

The holders of the lordship of Glamorgan and Cardiff, c.1181–1536.
The names of the holders and those heiresses through whom the lordship
passed are underlined.

end of St Mary's Street. There, it stretched across from Le Monde Restaurant and was pierced by the south gate. It then swung westwards towards the Taff, which was much closer in 1300 than it is now for, until its diversion in 1849 the river flowed alongside what became Westgate Street and through the site of the General (later the Central) Station. The wall continued along the banks of the Taff where it was pierced by two gates – Blount's Gate and the Golate – both of which gave access to the river's quays.

Cardiff in 1300 consisted of little more than the buildings within the walls. There was a dribble of houses at Crokerton beyond the east gate and a further dribble beyond the south gate at Soudrey. However, the only substantial buildings outside the walls were the town mills on the Taff west of the castle, the leper hospital in Crokerton and the friaries of the Dominicans and the Franciscans – Cardiff was the only Welsh town to have houses of both the orders. The black friars arrived in about 1242 and settled in Coopers Fields, west of the castle. Over the following decades, they built a church forty metres in length, a cloister, a refectory and an infirmary. What remains of it is now a melancholy sight – a few footings and a series of brick walls purporting to mark the plan of the church. The grey friars came somewhat later and established themselves to the north-east of the castle. It is impossible to see even the footings of their buildings. Following the friary's dissolution, a branch of the Herbert family acquired the buildings and erected a handsome house on the site. By the late eighteenth century, the house had fallen into ruin but, until 1967, a picturesque fragment of it continued to delight the hearts of passers-by. The foundations now lie beneath the Pearl Assurance building, the architects of which lacked either the imagination or the means to include in their plans at least a vestige of old Cardiff.

Thus, apart from the friaries and a few other buildings, Cardiff at the height of its medieval prosperity consisted of the buildings erected on the twenty or so hectares enclosed within the town walls. Its streets were probably lined with half-timbered houses, backing on the long gardens which occupied the wide burgages stretching between the town's few streets. (As the town would not grow for centuries, there was no motive to create additional streets. Thus the wide burgages were still intact in the

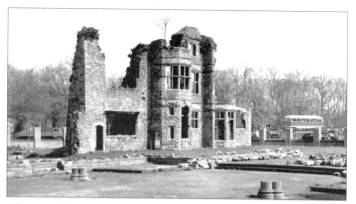

The ruins of Greyfriars House, photographed in about 1955. Built for Sir William Herbert in the 1580s on the site of Cardiff's Franciscan Friary, the ruins were demolished in 1967 to make way for the Pearl Assurance building.

late nineteenth century, providing the setting for the arcades which are among Cardiff's delights.) The houses accommodated an array of domestic crafts, including tanning, glove-making, metal-working, shoe-making, brewing and cloth-making. The skilled practitioners of the crafts were members of the guilds whose leaders were among the burgesses who met at the booth or town hall situated in the middle of the High Street, near the present NatWest bank. Further down, on the site of what was once the Prince of Wales Theatre, stood St Mary's, established as a Benedictine priory in about 1095 and rebuilt in 1175. As St Mary's was situated in the southern extremity of the town, and as its Taffside location made it vulnerable to flooding, its chapel-of-ease, St John the Baptist, situated in the heart of the built-up area, won increasing recognition as Cardiff's chief church. In 1300, its years of glory were yet to come; in that year, it was probably a modest chapel similar in size to that of St Piran, situated near the castle gate – Wales's only shrine to Cornwall's patron saint – and to that of St Nicholas, the family church of the lords of Cardiff, located in the outer ward of the castle.

Cardiff's population in 1300 of some two thousand would not be sustained. The early fourteenth century was a period of deteriorating climate and increasing economic crisis. In 1314,

Gilbert de Clare, the Red Earl's son, was killed at the battle of Bannockburn at the age of twenty-three. Royal officials took over the administration of the lordship of Glamorgan, and their high-handed ways aroused the hostility of the inhabitants of upland Glamorgan. The Clare family had used their challenge to the power of Llywelyn ap Gruffudd as an opportunity to bring the autonomous Welsh rulers of that region more firmly under their rule. Nevertheless, in upper Senghennydd, Miskin and Glynrhonddda, the inhabitants still lived in a world apart. In 1316, they rose in revolt under the leadership of Llywelyn Bren, a cultured man whose possessions included books in Welsh and French and who was probably the great-grandson of Ifor Bach. The revolt lasted only a few weeks, but it caused considerable devastation in the neighbourhood of Cardiff. From 1317 until his execution in 1326, Hugh Despenser held Glamorgan through the right of his wife, Eleanor, sister of Gilbert de Clare. It was he who insisted that Llywelyn should suffer the agonizing death of a traitor. His mangled body was buried in Greyfriars cemetery, but evidence of the grave disappeared during the friary's dissolution.

The following years saw some recovery. Cardiff was recognized as a head port or staple in 1326, allowing it a significant role, particularly in the wool trade. Its town hall was completed in the 1330s, and in 1340 its burgesses were granted a comprehensive charter. Yet the severe fluctuations in the fortunes of its ruling family, the Despensers, and the worsening of the economy boded ill. The Black Death of 1349 brought devastation, as did subsequent visitations of the plague. Then, in 1404, came the attack of Owain Glyndŵr. Major damage was caused; indeed, one account suggests that, with the exception of Greyfriars, the whole of the town was put to the torch. That was probably an exaggeration, but as late as 1492 rent arrears at Cardiff were ascribed to destruction 'in the time of the Rebellion of Wales in bygone days'.

Such were the troubles of the fourteenth and early fifteenth centuries that Cardiff did not regain the vitality it had shown in the thirteenth century. Despite that, the fifteenth century endowed Cardiff with two of its most significant buildings. The first was a major structure along the west wall of the castle, commissioned by Richard Beauchamp, earl of Warwick, lord of

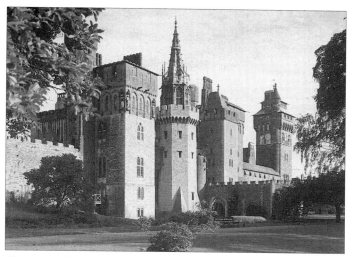

The western façade of Cardiff Castle. From left to right, the towers are the late eighteenth-century Bute Tower, the early fifteenth-century Beauchamp Tower, the late sixteenth-century Herbert Tower and the late nineteenth-century Clock Tower. The low wall with the arch is the 1921 reconstruction of Cardiff's west gate and part of the town wall.

Cardiff from 1423 to 1439 by right of his wife, Isabel, sister and heiress of Richard, last of the male line of the Despenser family. The Beauchamp work has been overwhelmed by subsequent building, particularly the vast refurbishment undertaken by the third marquess of Bute. Nevertheless, a walk along the castle's western outer façade will reveal its outstanding feature, a sturdy polygonal tower crowned by the fanciful flèche designed by William Burges in 1872. Backing on to the tower is the fifteenth-century domestic block built over the vaulted undercroft in which Cardiff's jolly medieval banquets are held.

The second of Cardiff's fifteenth-century buildings, and the only medieval survival within the old town, is the tower of St John's Church, whose handsome proportions and delightful pinnacles close the vista of Church Street with great panache. It is generally believed to have been commissioned by Isabel, duchess of Clarence, who held Glamorgan from 1471 to 1476.

Yet, as its style is similar to that of the so-called Jasper Tower of Llandaff Cathedral, built in about 1490, it may have been financed by Jasper Tudor, lord of Glamorgan from 1488 to 1495. The tower is perhaps Cardiff's best-loved feature and has long found approbation. As Rice Merrick put it in about 1580: 'A very faire steeple of grey ashlere, the workmanship of it, being carryed to a great heigth, and above beautifyed with pinnacles, of all skilfull beholders is very well liked of.'

With the death of Jasper Tudor in 1495, the marcher lordship of Glamorgan became the property of the Crown. By then, the whole concept of the March was becoming anachronistic. Through the so-called Acts of Union of 1536 and 1543, the privileges of the marcher lords were abolished and the March was divided into counties. The lordship of Glamorgan had long enjoyed quasi-county status, and territorially the act of 1536 involved little more than its expansion to include the lordship of Gower. As Cardiff was the county town, its superiority was much resented in Swansea. A shirehall was built within the outer ward of Cardiff Castle. It was the setting for those innovations of the Acts of 'Union' – the sittings of the courts of Great Session and the election of Glamorgan's two MPs (the member for the county and the member for the boroughs – Cardiff, Cowbridge, Llantrisant, Aberafan, Kenfig, Neath, Swansea and Loughor).

In John Speed's Cardiff map of 1610, the shirehall is delineated as a modest two-storey building and its footings are still visible on the castle lawn. The map also illustrates the aftermath of the Reformation: the roofless Blackfriars church, the handsome domed mansion occupying the site of the dissolved Franciscan friary, the ruined chapel of St Nicholas and the disappearance of the chapel of St Piran. The dissolution of the religious houses and the weakness of the secular church involved a significant transfer in ownership of land within the borough and in its immediate vicinity. The Herbert family of Swansea acquired the lands of Greyfriars and much of the Cardiff property of Tewkesbury Abbey, the monastery founded by Fitz Hammo where splendid tombs of the lords of Cardiff may still be seen. Tewkesbury lands at Llanishen and Lisvane became part of the estates of the Lewis family of Fan near Caerffili, as did the Margam Abbey grange which gave its name to Grange-

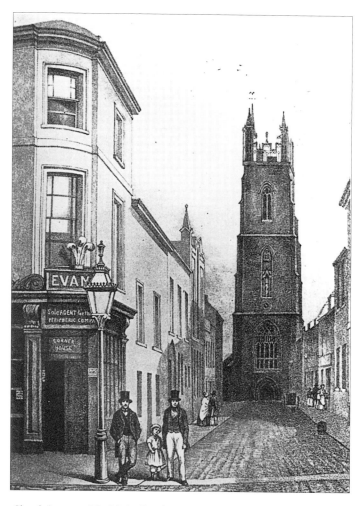

Church Street and St John's Church as portrayed in a lithograph of 1852. The Wesleyan Chapel, built in 1829, is visible on the left.

23

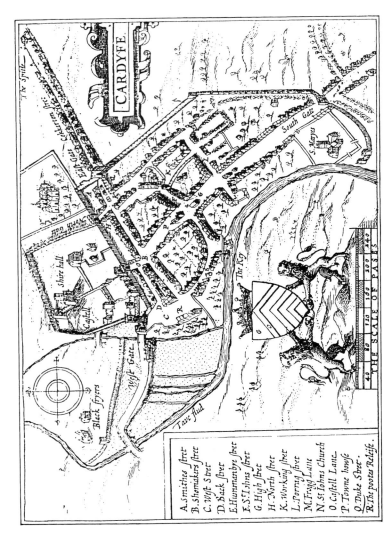

CARDYFE.

The Spittle

Cockharton strete

East Gate

Shire hall

Black fryers

Wyst Gate

Taw flud

South Gate

S. Mayes

The Key

THE SCALE OF PASES

John Speed's map of Cardiff 1610

24

town. The Lewises also acquired the lands of Keynsham Abbey at Roath, although they eventually passed to the Morgan family of Tredegar to become that area of eastern Cardiff known as Tredegarville. Margam's grange at Cathays came into the possession of the Carne family of Ewenni. The manor of Llandaff, the main source of the income of the medieval bishops, passed to the Mathew family of Radyr, while episcopal lands at Splott and Plasturton fell to yet another gentry family, the Bawdrips of Penmark.

While much of the old commote of Cibwr was passing into the ownership of relatively minor landowning families, the core of the commote – the castle – became the patrimony of a very grand family indeed. In 1547, William Herbert, a member of a cadet branch of the Herbert family of Raglan and brother-in-law of Henry VIII's widow, was granted lands in Glamorgan by the ten-year-old king, Edward VI, to whom he was governor. Further grants followed as a result of Herbert's role in the suppression of the Cornish Rising of 1549, and in 1551 he was elevated to the peerage as Lord Herbert of Cardiff and earl of Pembroke. So extensive was Herbert's property in south-east Wales that it was said that he 'could have passed through his own manors almost the whole of the way from the vicinity of Monmouth to Newton Down beyond Cowbridge . . . a distance of nearly sixty miles'. Edward VI's grants to him stated that he was to hold the lordship of Glamorgan 'in as ample a manner as [had] Jasper Tudor'. Yet, as the Acts of 'Union' had legislated that judgement of criminals was the prerogative of the Crown, there could be no re-creation of an old-style marcher lordship. Nevertheless, with their vast properties and their influence at court, the power of the Herberts in Wales was comparable with that of some of the mightiest of the medieval marcher lords.

That power made itself felt, above all, in Cardiff. The Acts of 'Union' had ostensibly liberated the towns of the March from the authority of the marcher lords. Furthermore, Cardiff's charters of 1600 and 1608 emphasized the liberties of the burgesses, confirmed the executive power of their representatives and granted the town its own justices of the peace independent of those of the county of Glamorgan. Yet, as a Herbert nominee, the constable of the castle was the titular mayor, and as only officials acceptable to the Herberts were appointed, there was

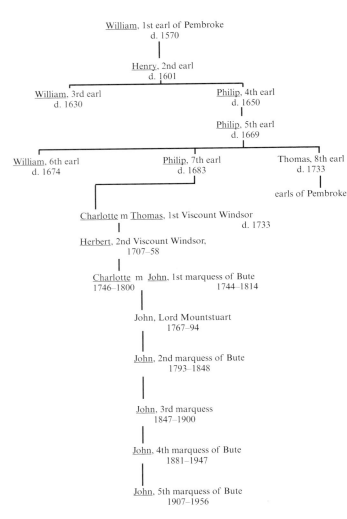

The family tree of the owners of Cardiff Castle, 1547–1947.
The names of the owners are underlined.

little substance to the much vaunted independence of the burgesses. In addition, Glamorgan's parliamentary representatives were generally drawn either from members of the Herbert family or from its close allies.

Despite the influence the Herberts enjoyed as lords of Cardiff, the town became increasingly marginal to their interests. The castle was the main centre of the first and second earls of Pembroke (1551–1601), with the second earl enlarging its residential quarters by commissioning the building of the Herbert Tower. The third and fourth earls (1601–50), the patrons of Shakespeare, found London and their splendid mansion at Wilton near Salisbury more to their taste and, under the following three earls (1650–83), the links with Cardiff became ever more tenuous. There was no more building at the castle, the fabric of which became increasingly dilapidated. Most of the Herbert properties in Monmouthshire were sold and, in Glamorgan, Herbert land was encroached upon, estate rights were usurped, and political influence plummeted. Symptomatic of Herbert priorities was the legal settlement of the estate, in which the Wilton estate was singled out as the property which should not be separated from the title of earl of Pembroke. Thus, when Philip, the seventh earl, a murderous alcoholic, died sonless in 1683, the Wilton estate was inherited by his brother Thomas, the eighth earl. The Welsh estates passed to Philip's daughter, Charlotte, who married Thomas Windsor, a member of a cadet branch of the Windsor family, earls of Plymouth. Thus ended the Herbert connection with Cardiff, although a recent earl of Pembroke is reputed to have owned a dog named Cardiff.

Evidence for the condition of Cardiff in the sixteenth and seventeenth centuries can appear to be conflicting. To John Leland, writing in the 1530s, it was 'the fairest town in Wales', although he noted that it lacked the importance of Carmarthen, 'the chiefe citie of the country'. Yet, in 1544, Parliament expressed its concern that the town had so many derelict houses. A survey of 1542 showed that Cardiff had 370 burgages, of which only 269 were occupied, suggesting that it was considerably smaller than it had been in the 1280s. Rice Merrick, writing in about 1580, praised its 'fair houses and large streets' and declared that 'within the Walles is little or noe vacant or wast

Ground . . . because it is so well replenished with buildings'. However, Speed's map of 1610 portrays a shrunken town, with much of the land within the walls given over to gardens and orchards. The most densely populated area was that around St John's, which, by the end of the sixteenth century, had been recognized as the church of a separate parish. The map of 1610 shows that the Taff had carried away a corner of the churchyard of St Mary's, but portrays an intact church; however, three years before the map's publication a great flood had undermined the building, which, over subsequent decades, collapsed into total ruin. (A somewhat fanciful outline of the church can be seen on the western façade of the former Prince of Wales Theatre.)

Speed's map was probably published at the time when early modern Cardiff was reaching its apogee, for there is evidence that the town enjoyed modest prosperity in the late sixteenth and early seventeenth centuries. Thereafter, for at least six generations, it stagnated. According to the hearth-tax returns of 1670, Cardiff had 341 hearths – marginally more than Swansea at 337 – a figure which would suggest that the town had hardly more than 1,500 inhabitants. Between 1670 and 1770, Cardiff may well have contracted in size. Although the town was revitalized in the last decades of the eighteenth century, the first official census – that of 1801 – recorded that its two parishes – St John's and St Mary's – had between them a total of 1,870 inhabitants. Thus, it would be reasonable to assume that the town's population in 1770 was less than it had been in 1670. There was no incentive to endow the town with new buildings. Indeed, William Gilpin, visiting Cardiff in 1770, declared that 'it appeared with more of the furniture of antiquity about it than any town we had seen in Wales' – although, apart from the castle and St John's Church, nothing of that 'furniture of antiquity' now survives.

Cardiff's centuries of stagnation are something of a puzzle, even in the context of the largely pre-urban society of early modern Wales for, in 1801, the town ranked twenty-fifth in size among the country's urban centres. Ostensibly, it had advantages which should have allowed it to prosper. It was the administrative centre of the richest of Wales's counties, it was recognized in 1559 as one of the three head ports of Wales, it lay astride a major road, it adjoined one of Wales's richest

28

agricultural areas and, from 1551 to 1683, its castle was a seat of one of the kingdom's wealthiest noble families.

Yet, in a pre-bureaucratic age, being an administrative centre brought little in the way of employment, and the legal capital of south-east Wales was not Cardiff, but the larger and more fashionable town of Brecon. Although Cardiff's Taffside quay exported a considerable part of the agricultural surplus of the Vale of Glamorgan to Bristol and elsewhere, the lively port of Aberthaw was more convenient for most of the Vale's farmers, and there was competition too from smaller ports such as Sully and Newton near Porthcawl. The capital of the Vale was Cowbridge not Cardiff, and to the Vale's most remarkable son, Iolo Morganwg (Edward Williams, 1747–1826), Cardiff was 'an obscure and inconsiderable' place. The road through Cardiff and the Vale was of secondary importance as a thoroughfare across south Wales compared with the more developed route which passed through Abergavenny and Brecon. The immediate vicinity of Cardiff offered little in terms of agricultural riches; there was some fertile land north of the town but the band of lowland was narrow; to the south, in the area between the town and the sea, lay a stretch of ill-drained cold clay lands which, until the great dock-building ventures of the nineteenth century, were totally uninhabited. With the Herbert family's increasing preference for Wilton, Cardiff Castle ceased to be a centre from which wealth and employment radiated. In places such as Alnwick and Arundel, households of resident aristocrats could inject as much as £10,000 a year into the local economy; by the last years of the Herbert connection, annual outgoings at Cardiff Castle had dwindled to a few hundred pounds a year, and expenditure declined further under the non-resident Windsor family, particularly following the death, insolvent, of the second Viscount Windsor in 1758. Above all, Cardiff profited little, initially at least, from the groundswell of industrial development which Glamorgan was experiencing by the early eighteenth century. Unlike Swansea and Neath where the coal seams reached the coast, Cardiff was some distance from exploitable minerals, and the town failed to attract men such as Humphrey Mackworth who played so crucial a role in the industrialization of west Glamorgan.

To Iolo Morganwg, Cardiff was 'an alien community which aped English manners'. Undoubtedly, it was alien originally, for

29

there were probably no native Welsh people among the inhabitants of the original borough. By the later Middle Ages, however, there is evidence that the town had Welsh residents. Names such as Gruffydd and Ieuan appear as burgage and tenement owners and, in addition, those with English names could have strong Welsh sympathies – John Sperhauke, for example, who was executed in 1402 for declaring that 'Owain Glyndŵr is the true prince of Wales'. In subsequent centuries, the town was progressively Cymricized. The names on a rental of 1542 suggests that 33 per cent of Cardiffians were of Welsh stock, a proportion which had risen to at least 50 per cent by the time of the compilation of the hearth-tax records of 1670. By then, there was a strong Welsh-speaking element in the town, people who gave their own names to some of its features – Porth Llongau (ship gate) to the south gate, for example, and Heol y Cawl (broth road) to Wharton Street. Furthermore, beyond the boundaries of St John's and St Mary's, the population of Cibwr was wholly Welsh in language, as the words quoted in libel cases brought by inhabitants of Whitchurch, Llanishen and elsewhere amply prove.

The Cymricization of the old borough was a protracted business and there can be no doubt that, in the first half of the sixteenth century, Cardiff was largely English-speaking. That might in part explain the town's prominence in the history of early Protestantism and Puritanism in Wales, movements which were slow to have an impact upon wholly Welsh-speaking communities. The only heretic known to have been burnt in Wales during the reign of Henry VIII was Thomas Capper of Cardiff, although, as knowledge of his execution is the result of the fortuitous survival of the town's accounts for 1542, there may have been others in Wales – in Cardiff indeed – who shared his horrific fate. Of the three heretics burnt in Wales during the reign of Mary I, one was the Cardiffian, Rawlins White. A memorial raised to him in front of Bethany Baptist Chapel in Wharton Street vanished from the street when the chapel was absorbed into the extension of Howells department store in the 1960s. It can now be seen in the store's menswear department nestling between the products of Crombie and Aquascutum.

Two of the pioneers of Welsh Puritanism – William Erbery and Walter Cradock – were Cardiff clergymen, and among Erbery's disciples was the remarkable Cardiffian, Christopher

Love, a zealous Presbyterian who was executed for allegedly plotting against the Cromwellian regime. Cardiff was among the first places in Wales in which Quakerism was preached and, in the 1660s, the Cardiff Friends acquired a burial ground which now lies beneath the Central Station. The town's Nonconformists took early advantage of the Toleration Act of 1689, erecting in 1696 a place of worship in Womanby Street, the mother church of Cardiff Congregationalism.

It was no doubt followers of Erbery and Cradock who were the 'schismatics of several kinds' who were accused during the Civil War of traducing the Book of Common Prayer and securing the abandonment of its use at church services at Cardiff. Fears that schismatics would turn the world upside down served to shore up Royalist support among the gentry of Glamorgan, although many of them were involved in the Peace Army which sought to save their county from being a battlefield, and the lord of Cardiff, the fourth earl of Pembroke, was a moderate Parliamentarian. Charles I made two visits to Cardiff in July 1645 (the next visit by a monarch would be that of Edward VII 262 years later) but, in February 1646, the town was besieged and captured by Parliamentary forces. During the Second Civil War – fomented by Royalists and disillusioned Parliamentarians – Cardiff again came under threat and such was the unrest in the region that Cromwell himself set out for Glamorgan. He arrived at Cardiff on 16 May 1648, eight days after the total victory of his forces at the battle of St Fagans, the most considerable engagement to take place in Wales during the civil wars.

The Interregnum gave further encouragement to Puritanism, and Cardiff's reputation for dissent and radicalism continued into the later seventeenth century. Thereafter, however, the town's political complexion became increasingly right-wing. Between 1690 and 1780, the Glamorgan Boroughs constituency, which was dominated by Cardiff, returned an unbroken succession of Tory MPs. The town's merchant class abandoned its struggle against gentry influence and instead coalesced with the county's ruling elite, which itself was changing as old landed families died out. While upland Glamorgan became, as Gwyn A. Williams put it, 'one of the nurseries of the democratic ideology of the Atlantic world', Cardiff turned its back on radicalism, a process aided by the town's close association with Bristol where

involvement with the slave trade – in which several Cardiffians participated – encouraged the growth of Tory sentiment.

Thus, by the end of the seventeenth century, Cardiff was a conservative community, an adjunct of the far larger port across the Severn Sea. Despite the fifty and more crafts and commercial activities pursued within its walls, it would for a century and more remain a primarily agricultural community. Although some pig iron and lead ore was exported from the town quay, its trade was dominated by the rural products of the Vale of Glamorgan. Furthermore, many of Cardiff's inhabitants were themselves agriculturalists, keeping cattle in backstreet byres and driving them south to graze on the marshy pastures of the Dumballs or north to the town lands of Cathays and the commons of the Great and Little Heath.

The town was somewhat uncouth. Following the closure in 1660 of the school established during the Interregnum, it would be devoid of educational institutions until the setting up of the Herbert Charity in 1707 and the Wells Charity in 1711, charities which provided funds sufficient to offer schooling to a handful of the town's children. Cardiffians could witness the hangings at the gibbet in St Mary's Street and the bull-baiting at the Bull Ring, on the site of the present statue of Aneurin Bevan. They could experience the harshness of the Poor Law and the horrors of the town gaol. They could be involved in the cruelties associated with piracy, the violence of factional feuds and the rowdiness of the many taverns – one for every twenty-five adult males. They were faced with the dangers of unlit and unpaved streets and the diseases caused by untreated sewage and contaminated water.

By the later eighteenth century, however, there were signs of new vigour. In 1760, the wall of the town quay was rebuilt to accommodate additional landing places, and two years later water bailiffs were appointed to supervise the quay's trade. In 1767, plans were prepared to remove the town gates in order to facilitate the flow of traffic through the town. In 1774, an Act of Parliament authorized work on the paving, cleansing and lighting of Cardiff's streets, and in 1778 the corporation began to proceed against those responsible for dung heaps and for allowing their pigs to wander.

This new vigour coincided with and was undoubtedly prompted by the growing prosperity of the port, where the

tonnage of shipping owned by Cardiffians doubled between the 1730s and the 1760s. It also coincided with the end of the link between the Windsor family and the Cardiff Castle estate. In 1768, Herbert, the second Viscount Windsor died, leaving two daughters. He bequeathed his estates, for her lifetime, to his wife, Alice, a member of the Clavering family of County Durham, a family prominent in the coal trade of north-eastern England. Following Alice's death, the estates were to go to his daughters, on the condition that neither of them married a Scotsman. Alice died in 1776, when the Windsor properties passed to the sole surviving daughter, Charlotte, despite the fact that she had married John, Lord Mountstuart, eldest son of George III's prime minister, the third earl of Bute, the best-known and most hated Scotsman of the age.

Lord Mountstuart held the Cardiff Castle estate until his death in 1812. In 1776, he was elevated to the British peerage as Baron Cardiff. Inheriting the earldom of Bute in 1792, he was promoted to marquess of Bute in 1796. His main involvement with his Glamorgan property was a determination to assert its political influence and to add to its acreage. His purchases cost him at least £30,000 and included the Cardiff Arms Hotel, the Adamsdown and Maendy estates and, above all, the Friars estate which extended over the whole of Cathays and the greater part of Cogan and Leckwith. Furthermore, he acquired much of the Great Heath following its parliamentary enclosure in 1801, and mortgage loans from him to Cardiff corporation were redeemed through the transfer to him of most of the town's holdings. By the 1840s, the Bute family owned 520 hectares within the parishes of St John and St Mary compared with the twenty-five hectares owned by the corporation. The acquisitions gave the Bute family an overwhelming predominance in Cardiff, and the eventual return on the investment was one of the largest ever enjoyed by a landed family. The marquess intended Cardiff Castle to be the seat of his eldest son and, to that end, he commissioned 'Capability' Brown to landscape its grounds and to make it into a more habitable residence. Brown demolished the wall between the inner and outer baileys and all the post-twelfth-century structures on the motte, and surrounded the castle with lawns and trees. With his assistant, Henry Holland, he added yet another tower to the western façade and recast the

residential apartments, giving them large Gothic windows. The recasting found little favour, one critic commenting that the result bore a strange resemblance to the Buteshire gaol at Rothesay. Building came to an abrupt end with the death of the marquess's heir in 1794 and, over the next three-quarters of a century, no work of significance was undertaken at the castle.

As the diary of John Bird, the marquess's Cardiff secretary, proves, the marquess showed no interest in the commercial life of Cardiff. Nevertheless, during the years of his ownership of the castle estate, the town's economic prospects were transformed. The key factor was the opening in 1794 of the Glamorganshire Canal linking Merthyr to Cardiff. Initially, the canal terminated in a basin adjoining the Taff and located just beyond the south gate at the site of the present-day streets, East Canal Wharf and West Canal Wharf. In 1798, however, a two-kilometre extension was completed, ending in a basin accessible to the Taff estuary by sea-lock. While a wagon drawn by four horses could convey two tons of goods, a canal barge drawn by one horse could convey twenty-five tons. Ships using the town quay could not exceed eighty tons and had to navigate the tortuous four-kilometre channel of the Taff; those using the sea lock could be up to two hundred tons and, at high tide, had direct access to the sea. Thus the venture brought about a revolution in transport. The canal was financed by the ironmasters of Merthyr where annual production of pig iron was, in the 1790s, approaching twenty thousand tons. The figure would treble in the decade following the opening of the sea-lock, thus greatly boosting Cardiff's export trade.

Laborious transport methods meant that, in the pre-canal age, it was uneconomical for Cardiff to export coal, a far less valuable commodity in relation to its bulk than iron. As the town's customs officer noted in 1782: 'No coal is exported from this port, nor ever will be, because of the expense of bringing it down from the interior part of the country.' With the opening of the canal, Cardiff began to export coal, a development which would dominate its history for a century and more, and one which would bring about its total transformation. The canal did not obtrude into the old town. Instead, it ran alongside the north road and then passed through a hundred-metre tunnel beneath Crokerton (now Queen Street) at a point where a wholly

apposite Venetian *palazzo* – Cardiff's most delightful Victorian building – was erected in 1878. From there, it hugged the town wall to the bottom of the later Mill Lane, where it turned due south on its route across the Dumballs to the estuary.

To nineteenth-century commentators on Cardiff, the opening of the Glamorganshire Canal represented the turning-point in the history of the town. As one of them put it, the venture gave 'a most notable impulse to the commerce of Cardiff'. In the 1790s, Cardiff was provided with its first bank, racecourse, printing press and daily mail-coach to London. A coffee room and a number of philanthropic societies were established, the church was repaired, improvements were made in street paving and the sea defences were completed. In 1796, after Cardiff had long suffered the dislocation caused by the dilapidated bridge across the Taff, a new bridge was built, slightly to the south of that built in the Middle Ages. (The position of the medieval bridge explains what can appear to be the odd location of the town's west gate.)

Yet, too much should not be claimed. In the first twenty years of the nineteenth century, Cardiff's population growth kept pace almost exactly with that of Bangor. A map of Cardiff drawn in 1824 shows that, although there was by then a greater density of building within the town, its layout differed little from that portrayed by John Speed in 1610. The growth it experienced – from 1,870 inhabitants in 1801 to 6,187 in 1831 – was largely attributable to its role as the port of Merthyr Tydfil. Yet, although dependent upon the coalfield for its increasing prosperity, the attitude of Cardiffians towards the volatile communities to the north was from the beginning characterized by suspicion tinged with hostility. That was in part because the boundary of the coalfield was some distance away from Cardiff, a marked contrast with Swansea where coalmining and heavy industries dependent upon coal provided employment for many within the town and dominated the economy of its immediate environs.

When unrest threatened at Merthyr in 1831, E. P. Richards, agent to the marquess of Bute and soon to become Cardiff's town clerk, wrote numerous letters to the marquess, the lord lieutenant of Glamorgan, giving full expression to the true Cardiffian's mistrust of the people of 'the hills'. After Merthyr rose in revolt, Richard Lewis (Dic Penderyn) was hanged in public in Cardiff's

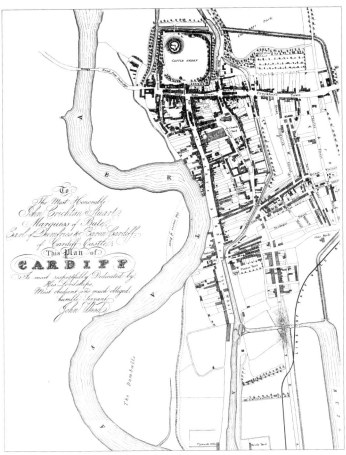

John Wood's map of Cardiff in the 1830s. In 1830, the town's confines were still very similar to those shown in Speed's map of 1610. Yet, by 1831, Cardiff had 6,187 inhabitants compared with less than two thousand in 1610. The additional population was accommodated in the densely built-up area developing immediately to the south of the castle, in the growing suburb of Crokerton and in the newly built streets, east and south-east of the Glamorganshire Canal. The map shows the course of the River Taff as it was before the diversion of 1849.

St Mary's Street, E. P. Richards expressing relief that the execution had passed off 'without the slightest noise or disturbance'. (A plaque commemorating the execution may be seen on the wall of the Central Market.) In 1839, there was great relief in Cardiff that it was the larger town of Newport which was targeted by the armed Chartists of the coalfield. Following the Chartists' uprising, the marquess of Bute insisted that troops should be stationed in Glamorgan, an insistence which led to the establishment of Cardiff's barracks at Longcross on Newport Road in 1843.

Suspicion of the coalfield community has remained a characteristic of Cardiffians until today, despite the fact that, but for the coalfield, Cardiff would never have been more than a Taffside village. It was the wealth of the coalfield which motivated the crucial event in Cardiff's history – the completion in 1839 of its first masonry dock. The dock led to the town's take-off into rapid population growth. Two years after it was completed, Cardiff was still only fourth in size among the towns of Wales and was only marginally ahead of towns such as Carmarthen, Caernarfon and Pembroke. Thirty years later, it had outstripped all its rivals.

Cardiff's present urban landscape offers indications of the town's modest growth in the first half of the nineteenth century and its meteoric expansion in the second half. Anyone seeking evidence of Georgian Cardiff will be disappointed for, in the old town centre, virtually nothing built between 1790 and 1840 is now visible. This suggests either that the helter-skelter growth of the subsequent decades led to the wiping out of the achievements of the previous half century, or that, in that half century, so modest was the town that nothing worth preserving was built. Apart from the castle and St John's Church, Cardiff's only buildings predating the 1840s are a few eighteenth-century houses in Duke Street and the Old Bank building of 1835 at No. 5 High Street. This is in marked contrast with Swansea with its early nineteenth-century terraces at Prospect Place, Cambrian Place and Gloucester Place, its Assembly Rooms of the 1810s, its Guildhall of the 1820s and its superb Royal Institution of 1839 – not to mention the intact eighteenth-century town planning at Morriston. With the exception of the astonishing Millennium Stadium and a few other buildings – the Howells store extension of 1930, for example, or the Central Station of 1934 – architect-

urally Cardiff's old town centre is overwhelmingly Victorian. Its councillors had a point when they congratulated Victoria on the occasion of her Diamond Jubilee in 1897. 'Cardiff', they declared, 'proudly terms itself a Victorian town.'

The 1839 masonry dock was conceived, commissioned and financed by a single individual. He was John Crichton Stuart, who in 1812 inherited the titles and property of his grandfather, the first marquess of Bute. The venture was highly speculative and worries over his investment undoubtedly shortened his life. He died in 1848 at the age of fifty-five, a year after his second wife, Sophia, had given birth to a son. By then, the increasing returns from the dock, and income from developments stimulated by the dock's construction – in particular, ground rents at Cardiff and mineral royalties from the coalfield – meant that the Bute estate was no longer beyond the limits of indebtedness. During the long minority of the third marquess, the estate's income soared. The second marquess had stated in 1844: 'I am willing to think well of the prospects of my income in the distance.' His optimism was fully justified, but that income was not to be enjoyed by him.

The first dock and the four docks built later remained primarily a Bute family concern until 1922. That was also the case until 1938 with much of the land upon which Cardiff was built. Furthermore, it was only in 1947 that the family gave up ownership of the castle and its vast park in the very heart of Cardiff. The family's activities place it in the front rank of aristocratic entrepreneurs and city-makers. Of the British cities in whose development a single landowning family played a predominant role, Cardiff is undoubtedly the largest. As the *Daily Chronicle* put it in 1900: 'There is probably no similar estate in the country where an immense commercial centre has been fostered on one man's property, and the rights of the landlord preserved . . . intact.' The fostering began with the second marquess and won for him the accolade of 'creator of modern Cardiff'. It is fitting that his statue, first erected in 1853 in front of the town hall in High Street, and later moved to the bottom of St Mary's Street, now graces Bute Square, a pivotal feature of Cardiff's redevelopment.

The dock of 1839 received its water from a feeder which tapped the Taff at Blackweir. The feeder was the only physical

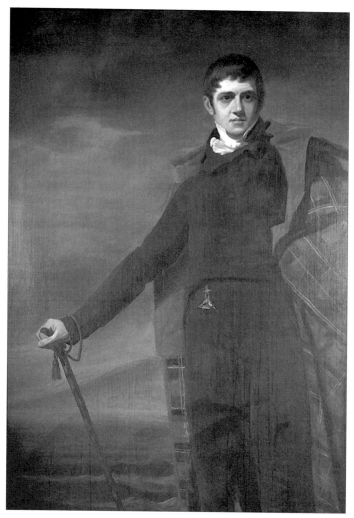

Raeburn's portrait of the second marquess of Bute. It was painted in 1818 when the marquess was twenty-five.

impact upon the old town brought about by the construction of the dock. It can still be seen in Bute Park where it is linked to the castle moat. Sections of it are also visible south of Boulevard de Nantes, but an attractive section is now covered over by Churchill Way; bringing that section back to view would much enhance a rather nondescript street. Hardly had the work on the feeder been completed when work on the Taff Vale Railway began. The railway lay slightly to the east of the feeder and its construction involved the erection of a bridge across the road traversing Crokerton.

Cardiff's next major innovation, the South Wales Railway, opened in 1850. It had a far greater impact upon the topography of the old town. Its building involved the straightening of the Taff, thus completely changing the appearance of the western side of the borough. Part of the old channel became the site of the station, but most of it was for decades a noxious bogland; it eventually became Wales's most renowned piece of real estate – Cardiff Arms Park. The construction of the South Wales Railway also involved the building of a high embankment along the southern edge of the old town, an embankment insisted upon by the second marquess who was determined that the roads leading from the town to the dock should not be intersected by level crossings. The embankment created a barrier between the old town and the other Cardiff which was developing around the dock, a barrier which Rhodri Morgan has described as Cardiff's Mason-Dixon Line.

A Glamorganshire Canal barge could carry from Merthyr to Cardiff a load of twenty-five tons six times a month. The Taff Vale Railway could carry far more than a barge's entire monthly load in little more than an hour, and the loads multiplied rapidly, especially after 1855, the year in which the first train conveyed Rhondda steam coal to Cardiff. This new revolution in transport caused the tonnage handled at Cardiff to rise from 117,639 in 1841 to 1.868 million in 1859, the year in which the port's second dock, the East Bute, was completed. The vast expansion in the activity of the other Cardiff could not but have an impact upon the old town. In particular, it brought in a flood of immigrants. Many of them came from the overwhelmingly Catholic counties of southern Ireland, much to the distress of the staunchly Protestant Sophia, marchioness of Bute. ('Why', she is reputed to have asked

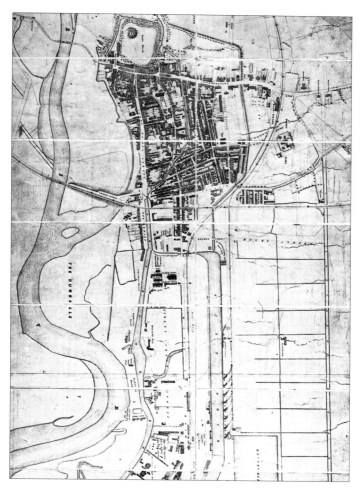

Cardiff in 1849. Compared with the map of the 1830s, the greater density of building within the old borough is immediately apparent, as is the growth of Newtown to the south-east of the canal. The map shows the diversion of the river and the layout of the Taff and South Wales Railways. Apart from the prison and three short streets, there was as yet no development to the east of the Taff Vale Railway. Building was developing apace at both ends of Bute Street.

41

her husband, 'can we not recruit workers from the Protestant part of the island?') By 1851, some 30 per cent of the inhabitants of the old borough had been born in Ireland. Most of them had fled from famine and had been carried to the port as ballast on ships returning from conveying coal to Cork and Waterford. The percentage was higher than that of any other British port, and the fact that Cardiff received virtually no immigrants from 'the Protestant part of the island' meant that it was spared the Green–Orange conflict which plagued ports such as Liverpool and Glasgow. The social standing of Cardiff's Catholics was enhanced when the third marquess of Bute, on his twenty-first birthday in 1868, announced that he had been received into the Roman Catholic Church. As perhaps Britain's richest young aristocrat, his conversion was considered to be British Catholicism's 'greatest ever stroke of luck'.

The Irish and other impoverished immigrants settled in Newtown, the network of mean lanes and closes in the southern part of the old town around Mary Ann Street, an area now dominated by the Dublin-owned Jury's Hotel. T. W. Rammell's report of 1850 on the sanitary condition of Cardiff luridly describes the appalling conditions under which they lived. The report led to the establishment of the Cardiff Board of Health, much to the annoyance of E. P. Richards. He considered the board to be a rival focus to the corporation which, despite the Municipal Corporations Act of 1834 that ostensibly made town councils answerable to ratepayers, was still dominated by the Bute estate. The estate suffered a further blow in 1852 when Cardiff's Bute-sponsored Conservative MP, John Nicholl, was defeated by the Liberal coalowner, Walter Coffin. The following year, the radical, John Batchelor, was elected mayor of Cardiff; Batchelor would be the leader of the town's anti-Bute faction until his death in 1883 when his admirers raised a statue to him as 'The Friend of Freedom'. In 1857, a weekly newspaper, the *Cardiff Times*, was founded specifically with the aim of delivering Cardiff from 'the degrading position of being a mere appanage of the Bute estate'.

Despite the erosion of the estate's political power, it still retained enormous influence, particularly over the alignment of the streets and the layout of the houses of the growing town. The tenurial system it adopted was the ninety-nine-year lease

T. W. Rammell's Report on the Sanitary Condition of the Town of Cardiff, 1850

In 1848, Parliament passed the Public Health Act, which sanctioned the setting up of a local board of health in those areas where there was a significant demand for such an innovation. A petition signed by more than one-tenth of Cardiff's rated inhabitants demanded a board, and in 1849–50 T. W. Rammell, a Board of Health inspector, investigated the borough's sanitary condition. His investigation coincided with an epidemic; cholera and diarrhoea killed 383 of the town's inhabitants, 62 in the parish of St John and 321 in the parish of St Mary.

Rammell's *Report* includes the following quotations and observations:

> Nothing can be worse than the house accommodation for . . . the poor in this town; the overcrowding is fearful, beyond anything of the kind I have ever known of.

> I inspected no. 17 Stanley Street . . . I counted the persons living in the house; there were 54 persons, men, women and children; they live, eat and sleep all in one room. The smell arising from the overcrowded room was most overpowering.

> The well [in Mary Ann Street] . . . is used for drinking . . . I have seen worms in it; the people clamber over the wall for this water, it is like a struggle for life and death.

> In Waterloo Buildings in the Hayes, there are 11 or 12 houses with two privies; one was full up to the seat board . . . People go of a night anywhere they can.

> The [burial] ground [of St John's Church] is excessively crowded . . . Persons dying of typhus fever are frequently interred with no more than two feet of soil above them.

Cardiff's local board of health was established in 1850. Elaborate schemes for reform were instituted, but decades were to go by before the evils uncovered by Rammell were rectified.

developed in London following the great fire of 1666. The system had its merits. As the estate retained an interest in the land built upon, its officials undertook the task of laying it out in a coherent manner, a virtue absent from those few parts of Cardiff where there was piecemeal selling of freehold plots. Furthermore, for a house purchaser, the price of the plot was not a component of the price of the house, a consideration which may have increased the number for whom owner occupation was affordable. The ninety-nine-year lease was also adopted by Cardiff's other main landed families – the Morgans of Tredegar House, the Windsors of St Fagans, the Richardses of Plas-newydd, the Crofts Williamses of Roath Court and the Homfrays of Penllin Castle – causing the town to be one of the great strongholds of the leasehold system. The system had its drawbacks also. As leaseholders were subject to the numerous covenants laid down by the lessors, they felt they were denied the full dignity of ownership, and they resented their obligation to pay ground rent – about £3 a year for a modest terraced house and several hundred pounds for a substantial commercial building. Above all, when a lease expired, the land and any building erected upon it reverted to the landlord, a cause of much anxiety in the mid-twentieth century as the ninety-nine-year-leases of the 1840s and 1850s ran out. (Cardiff's problems led to the Leasehold Enfranchisement Act of 1967, but the issue has not yet been fully resolved.)

As the core of the old town was in fractured ownership, and as the alignment of the streets of that core had long been estab-lished, the Bute estate was denied the opportunity to refashion the area between Crokerton and St Mary's Street, an area considered in 1850 to be 'a most unlovely place, with narrow tortuous streets, the principal ones blocked with dilapidated buildings'. Indeed, it could be argued that it was in its negative rather than its positive actions that the Bute family made its most outstanding contribution to the topography of Cardiff. As it was wealthy enough not to feel the need for the massive ground rents which would have accrued from building on the open spaces north of the castle, the family secured for Cardiff its greatest glory – its vast green heart.

However, the positive actions of the Butes should not be ignored. The second marquess vetted all layouts of prospective

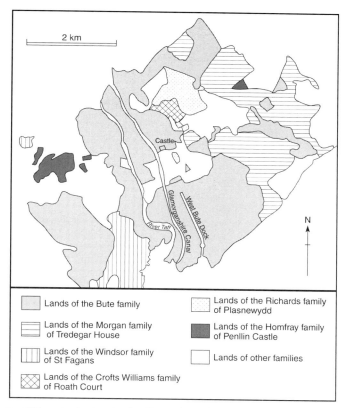

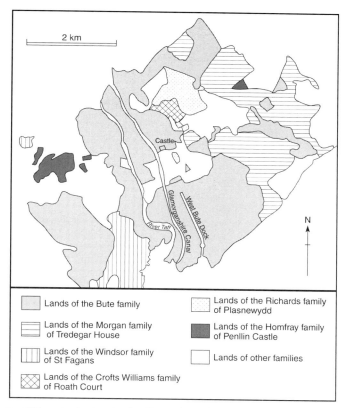

The legend reads:

- Lands of the Bute family
- Lands of the Morgan family of Tredegar House
- Lands of the Windsor family of St Fagans
- Lands of the Crofts Williams family of Roath Court
- Lands of the Richards family of Plasnewydd
- Lands of the Homfray family of Penllin Castle
- Lands of other families

*Cardiff's major landowning families in the mid nineteenth century.
(After M. J. Daunton, 1977)*

buildings; in 1837, for example, he insisted that the proposed
Windsor Place should be widened and the windows of its houses
adequately spaced, and the result of his insistence can still be
appreciated in that handsome street. His son's trustees proved
equally meticulous, ensuring that even small houses had front
gardens and establishing squares which, as a Bute agent put it,
'provide a little breathing space'. This policy reached its apogee
in 1887 with the designation of the valley of the Roath Brook as

a public park, a designation which permitted the estate to charge substantially higher ground rents for the houses overlooking the park. Even its left-wing opponents were obliged to admit that the Bute estate built well. In 1907, the pioneer town planner, Professor Jevons, declared that the estate's 'building regulations . . . are well enforced, so that weak or insanitary construction is hardly to be found'. Indeed, the main complaint against the Butes was that they insisted upon work of too high a standard, thus ensuring that Cardiff contained few houses which working-class families could afford.

A marked feature of the Bute estate's activity was the way in which it ensured that street and other names emphasized Cardiff's links with the family. Bute properties gave their names to Adamsdown, Pen-y-lan, Maendy, Cathays, Rhydypennau, Blackweir and Pontcanna, and major features of the town – Bute Park, Sophia Gardens, Ninian Park and Cardiff Arms Park among them – have Bute associations. The titles of the family – Bute, Dumfries, Windsor, Mountjoy, Crichton and Mountstuart – appear on streets, places, crescents and squares. The names of their predecessors as lords of Cardiff, including Clare and Despenser, are recalled in the streets of Riverside. Streets in Cathays – Miskin, for example, or Glynrhondda – bear the names of the manors of the family's Glamorgan estate and, in Adamsdown, Sanquahar Street, Cumbrae Street and others bear those of Bute properties in Scotland. The first wife of the second marquess has a Guilford Street and his second a Sophia Street and a Loudoun Square. Glossop Terrace, Fitzalan Place and Howard Gardens have associations with the third marquess's wife, and Colum Road, Ninian Road and Lady Margaret Terrace are named after her children. The family's advisers on dock matters, Rennie, Stephenson and Smeaton, have streets in Riverside as have the dock engineers, Pomeroy and Hunter, at Pierhead. The Bute agents, Richards, Bruce, Tyndall, Corbett, Ryder, Pitman, Talbot, Sneyd, Clark, Lewis and Collingdon, all have at least one street apiece. Indeed, there can be few places where the imprint of a single family is as legible as is that of the Bute family at Cardiff.

The Bute initiative in the dockland brought about a change in the balance of population between the parishes of St John and St Mary. By the early 1860s, the lower part of St Mary's parish,

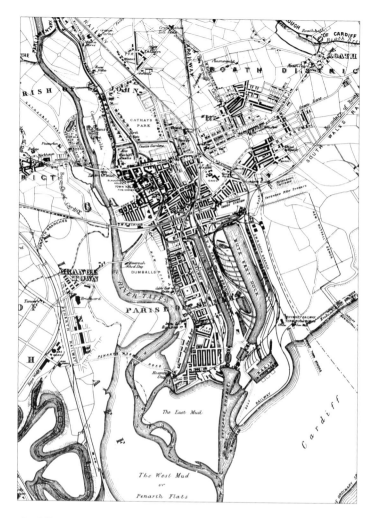

Cardiff in 1869. Compared with the map of 1849, the map shows the extensive urbanization of Butetown, the growth of Adamsdown and the beginnings of street building in Roath, Canton and Grangetown.

long an uninhabited moor, was becoming intensively urbanized. A map of 1869 shows that the town had at last moved beyond the confines portrayed by the maps of 1610 and the 1830s. By then, the proportion of the inhabitants of Cardiff's built-up area dwelling within the town's original parishes was declining. In the 1850s, although the population of the two parishes rose by 80 per cent, the population of the parishes of Roath and Llandaff rose by 325 per cent. That Cardiff had ceased to consist merely of its original parishes was recognized in 1875 when the borough was expanded to include the parish of Roath, the southern part of the parish of Llandaff and part of the parish of Leckwith, districts which in 1871 had 17,827 inhabitants compared with the 39,536 dwelling within the old boundaries. Cardiff's population percentage increase was 80 in the 1850s, 74 in the 1860s, 44 in the 1870s, 57 in the 1880s and 28 in the 1890s. By 1901, 164,333 people lived within the boundaries of Cardiff, eighty for every one who had lived in the old borough and its immediate environs a century earlier, a transformation which led to rhetoric hailing the town as 'the Chicago of Wales'.

Much of the population increase came from natural growth within the town itself, but incomers accounted for a high proportion. Many of them were natives of neighbouring Glamorgan and Monmouthshire parishes, the continuation of a process which had been afoot since the Middle Ages. Increasingly, however, they came from more distant parts of Wales, the census of 1881 showing that Cardiff had some 9,300 inhabitants born in Welsh counties other than Glamorgan and Monmouthshire. Yet, in that year, the town had forty thousand inhabitants born in England. Even in 1851, when much was made of the migration from Ireland, Cardiff's English-born migrants exceeded those born in Ireland. In 1881, the English-born proportion was 30 per cent, a year when the Irish-born were a mere 5 per cent – although the element in the town which considered itself to be Irish was considerably higher. Substantial emigration from England and the fact that south-eastern Glamorgan had long been more Anglicized than the western part of the county gave rise to harsh comment in Swansea, where it was frequently stated that Cardiff had no claims to be a genuine Welsh town.

Yet, every census recorded that the majority of the inhabitants of Cardiff had been born in Wales. In the 1830s, the town was

bordering upon being a largely Welsh-speaking community, with four of its seven Nonconformist chapels holding their services in Welsh and with the corporation insisting upon appointing a Welsh-speaking market clerk. Cardiff's ability to attract longer-distance migrants changed the situation, but the Welsh language continued to be a significant factor in the life of the town, and even more so in parishes which would eventually be brought within Cardiff's boundaries. In 1891, when 11 per cent of the inhabitants of the town itself claimed to have a knowledge of the language, the percentage was 57 in Llanedern and 65 in Lisvane. In that year, Cardiff had at least a dozen Welsh-language chapels; its Cymmrodorion society was a powerful force and its library was amassing Wales's largest collection of Welsh books and manuscripts. Many Cardiffians, however, did not warm to that landmark of Welsh distinctiveness, the Sunday Closing Act of 1881. In 1882, the owners of the Old Brewery, founded in St Mary's Street in 1713, sold up in disgust. (The brewery was bought by S. A. Brain.) By 1886, the town had 141 clubs, established specifically to circumvent the Act, and illegal shebeens sprang up by the hundred.

Despite Cardiff's rapid expansion, it was still, in the 1870s, only thirtieth in size among the towns of Britain. It was in that decade that its inhabitants decided that there was more dignity in being Wales's principal urban centre than in being merely one of a host of provincial towns. In 1873, it was referred to for the first time as 'the metropolis of Wales', a concept which would increasingly appeal to Cardiffians and one which, when made manifest in the twentieth century, would become central to Cardiff's prosperity and identity. As the town was becoming overwhelmingly English in speech, the self-styled Welsh metropolis had to create a new definition of Welshness. As Neil Evans has argued, Welsh patriotism expressed in English – now Wales's predominant form of patriotism – is a Cardiff invention. That patriotism found expression in the *Western Mail*, the daily newspaper founded in 1869 by Bute estate officials, who believed that their Conservative candidate had been hampered in the general election of the previous year by the lack of local press support. (Similar motives had prompted the second marquess to found east Glamorgan's first weekly newspaper, the *Cardiff and Merthyr Guardian*, in 1832.) It is one of the ironies of Welsh

Population

The race for supremacy among the towns of south Wales, 1801–1901.

history that the publication which claims to be the national newspaper of Wales owes its origin to Tory landlordism and has a name based upon the assumption that an urban centre in eastern Wales is a place that can be defined as western.

Cardiff's claims to be the metropolis of Wales – or at least of south Wales – were put to the test in 1882 in the debate over the location for south Wales's university college. Had the choice been made a decade earlier, Swansea, long Wales's most distinguished intellectual community, would undoubtedly have been the victor. It was in the 1870s that Cardiff decisively triumphed over Swansea in terms of population, a decade in which Cardiff, as Gwyn A. Williams put it, 'turned from a counting house into a community'. In its bid for the college, Swansea noted that there were 292,000 people living within a twenty-mile radius of the town. If Monmouthshire were not considered to be part of Wales – and in the 1880s, it was not generally so considered (the Welsh Sunday Closing Act of 1881, for example, was not initially operative there) – then, within Wales, the number living within a twenty-mile radius of Cardiff was roughly similar. In order to emphasize its population advantage, Cardiff was obliged to argue that Monmouthshire was a Welsh county, for that would mean that the town and its immediate hinterland had 474,000 inhabitants living in Wales. To Swansea's intense annoyance, the argument was accepted and, thereafter, the county was almost invariably considered to be part of Wales. Thus did Cardiff's need ensure Wales's territorial integrity. Much to the delight of the townspeople, Cardiff's bid was successful, partly because the marquess of Bute backed the bid with an offer of £10,000 – a paltry sum compared with the gifts made to colleges by English plutocrats, but far greater than anything Swansea was able to attract.

By 1883, the year the college opened, the number of inhabitants dwelling within the old boundaries was contracting sharply as central Cardiff was ceasing to be primarily a residential district and was becoming the location of shops, offices and institutions. These developments brought about a huge building boom, and indicative of the rapid growth are the photographs of ambitious buildings cheek by jowl with terraced cottages. As John Newman put it, 'the growth of Cardiff attracted architects like moths to a flame'. Change became apparent in 1861 with the

51

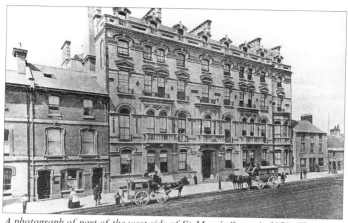

A photograph of part of the west side of St Mary's Street in 1870. The Royal Hotel, completed in 1866, appears as a massive pile alongside modest houses and tiny cottages.

removal from the middle of High Street of the mid-eighteenth-century town hall, and its replacement by a classical building on the west side of St Mary's Street. (The building was demolished in 1905, but a stone model of it graced the gable of the Criterion tavern until that building was pulled down in the 1970s.) Thereafter, for half a century and more, hardly a year passed without central Cardiff being endowed with a significant new building. Perhaps the most attractive feature of the old town is its arcades, the first of which, the Royal Arcade, was completed in 1858, and the most delightful, the Castle Arcade, in 1887. Among the memorable buildings are the unnerving polychrome Great Western Hotel of 1875, the already mentioned delectable neo-Venetian building of 1878, the solid market buildings of 1891 and the idiosyncratic Free Library of 1896.

Like so much in the history of Cardiff, the old town's most remarkable architectural feature is the result of the initiative of the Bute estate. In 1865, the third marquess, then only eighteen, began discussing with the architect, William Burges, the re-fashioning of the castle. The work began in 1868 and was continued, after the death of Burges in 1881, by his assistant, William Frame, with the marquess providing active collabora-

The view of Cardiff from Cefn Cibwr.

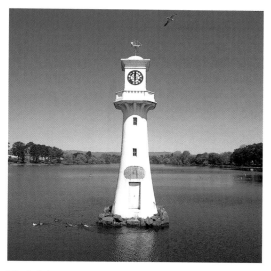

The lighthouse erected at the south end of Roath Lake in 1912. It commemorates Captain Scott's doomed Antarctic expedition which set out from Cardiff in June 1910.

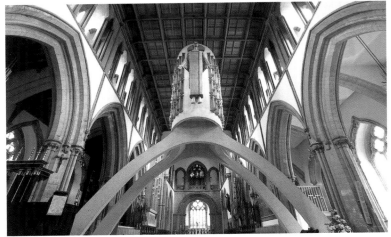

The interior of Llandaff Cathedral, showing George Pace's concrete arch and Jacob Epstein's Majestas.

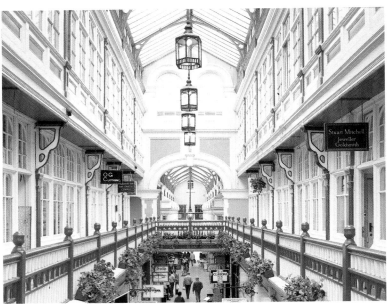

The Castle Arcade. The most delightful of the city's arcades, it was built in 1887.

The Norwegian Church. In the late nineteenth century, Norway had one of the world's largest merchant fleets. Erected near the pierhead in 1889, the church was considered to be 'the cosiest and most beautifully kept Seamen's mission in all Britain'. Derelict by the 1980s, it was reconstructed on a new site adjoining the Roath Basin in 1992.

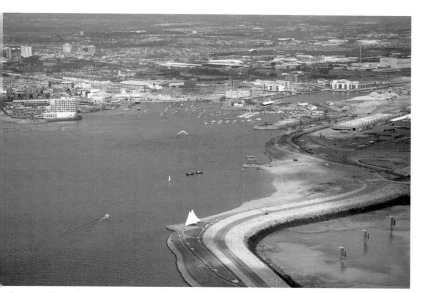

The Cardiff Bay barrage. Completed in 2001, it encloses a lake occupying the estuaries of the Taff and Ely rivers.

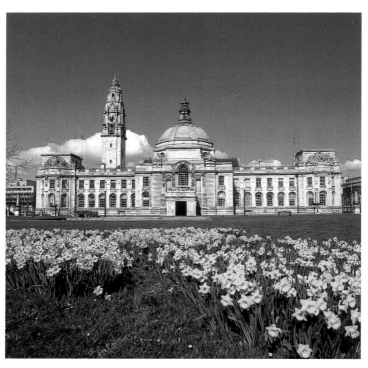

*The City Hall,
offering a view of
the snarling dragon
crowning the dome.*

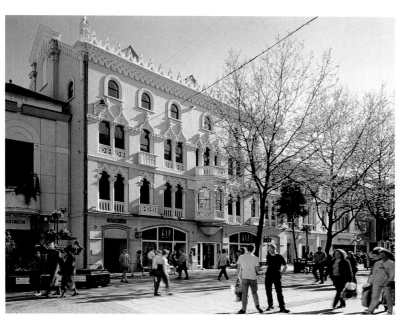

Present-day Queen Street. On the left is C. E. Bernard's scholarly reconstruction of a Venetian Gothic palace, erected in 1878. When built, it stood on the banks of the Glamorganshire Canal.

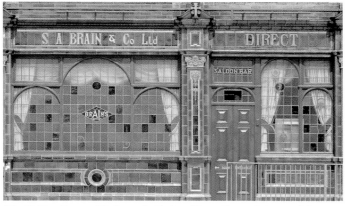

The Golden Cross public house in Custom House Street. It is one of the earliest Brains' taverns and contains fine murals of Cardiff Castle and the old town hall.

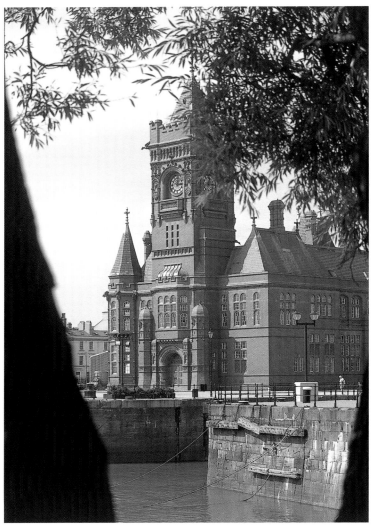

The Pierhead Building. It was completed in 1897 to the designs of William Frame, the one-time assistant of William Burges. Built as the headquarters of the Bute-founded Cardiff Railway Company, it is now the information centre of the National Assembly for Wales.

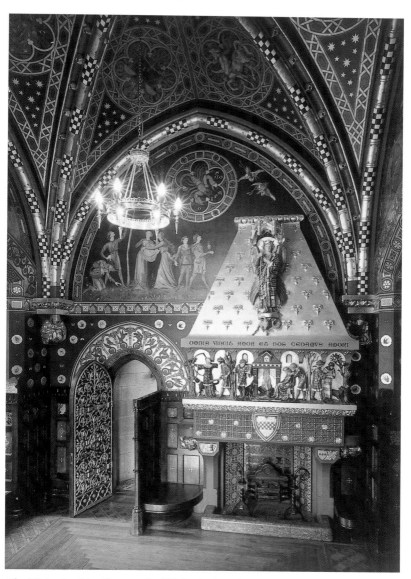

The Winter Smoking Room at Cardiff Castle. Completed in 1872, it was the earliest of the rooms constructed to the designs of William Burges. Its decoration is based on the theme of Time.

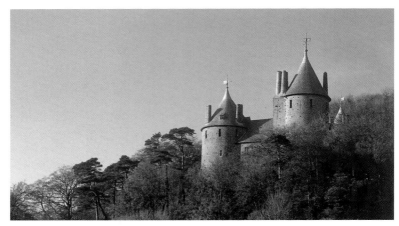

Castell Coch. William Burges began his reconstruction of the thirteenth-century castle in 1874. It was completed in 1891, ten years after Burges's death.

The Millennium Stadium, completed in 1999.

tion and, above all, almost an infinity of money. The result, to quote John Newman, is 'the most successful – and certainly the most enjoyable – of all the fantasy castles of the nineteenth century'. Externally, the most striking achievements are the splendid clock tower and the fabulous flèche surmounting the Beauchamp Tower. Mention has already been made of the delights of the reconstruction of the curtain walls. The reconstruction involved the removal of an accretion of buildings in Duke Street, thus providing the location for what is perhaps Cardiff's most captivating feature, the Animal Wall.

Inside the castle, Burges's work almost beggars belief. So opulent and intricate are the Chaucer Room, the Arab Room, the two smoking rooms, the library and the

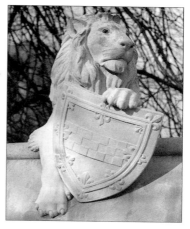

The Animal Wall was built in the 1880s. Among the animals are two lions bearing the Bute arms. The lions were put in place in 1888, but were later retouched following the marquess of Bute's comment that the originals were 'too modest in demeanour, savouring of pets rather than of roaring lions'. The wall originally flanked the castle entrance. It was moved to its present position in 1930.

banqueting hall that, in a more austere age, they aroused strong antipathy. To the Georgian enthusiast, James Lees-Milne, Cardiff Castle was an aberration, and in 1946 he suggested that Burges's work should be demolished. A later age takes a more generous view, and Cardiff is now considered to offer the fullest experience of 'the high Victorian dream'. Burges's work and influence were not restricted to the castle. He also rebuilt Castell Coch and designed a house for John McConnochie, the dock engineer. The impact of his interpretation of lordly medievalism left its mark on mansions and places of worship in and around Cardiff and, above all, in splendid streets such as Cathedral Road.

As work on the residential wing of the castle was coming to an end, Cardiff was launching even more ambitious architectural schemes. In 1897, the marquess of Bute sold to the corporation twenty-four hectares of Cathays Park as a site for public buildings. The corporation's primary intention was to erect buildings to fulfil the administrative, legal and scholastic needs of Cardiff as a town and as the capital of Glamorgan. However, from the beginning, there was an implicit intention of enhancing Cardiff's position as 'the Welsh metropolis', even to the extent of suggesting that the northernmost part of the park would eventually be the site of Wales's parliament. The corporation moved rapidly to achieve its aims. As soon as the purchase had been completed, competitive plans for a town hall and for law courts were sought and two wide avenues were laid out. By 1904, building was well advanced, and handsome lamp standards had been erected proudly bearing the words *Villa Cardiff* – the town of Cardiff. The erection was untimely, for within a year Cardiff had ceased to be a town.

3 The Other Cardiff

Whereas the old town has always been known as Cardiff, the other Cardiff has attracted a litany of names. Two hundred years ago, it was referred to as the town moor, or the lower part of St Mary's parish or the estuary. Later it became known as Butetown or the Docks or Tiger Bay or the district below the bridge and, now, the dull epithet, Cardiff Bay, has been thrust upon it.

Explorers of the Bay should follow the route taken by the Glamorganshire Canal, the undertaking which began the transformation of the district. (Sadly, little of the undertaking can now be seen within the boundaries of Cardiff for, apart from a tranquil stretch at Whitchurch, the entire canal was filled in during the 1950s.) Following the route involves walking down East Canal Wharf to the long narrow area of grass which leads to Clarence Road. From there, the canal ran west of Mountstuart Primary School and east of the Hamadryad Hospital. Those wishing to go to the place where the canal entered the Taff estuary should walk along the Butetown Link Road and stand at the point where the road becomes a bridge. That is, perhaps, a futile exercise, for the link road has obliterated both the canal's access to the estuary and the sea-lock pond where the world's ships were once loaded with the products of the world's largest ironworks.

The completion of the canal did not result in the immediate development of Cardiff's southern moors. More than twenty years after the opening of the sea-lock pond in 1798, the moors were still open fields, the townspeople complaining in 1822 that the pond's iron-laden wharfs were a nuisance to those driving cattle from the town's backstreet byres to graze on the salt marshes. In 1828, the second marquess of Bute commissioned James Green to suggest a layout for an ambitious masonry dock alongside the canal. Green's plan shows that the moors contained no structures at all apart from a glass-making factory and the wharfs along the sea-lock pond.

In commissioning the plans, the marquess was motivated by the fact that the ten thousand tons of iron handled by the port of

Cardiff in the late 1790s, had increased eightfold by the late 1820s, when Cardiff had become Britain's leading iron-exporting port. In addition, the coal exported by the port had risen from virtually nothing to a tonnage level similar to that of iron. The port's freighters were insistent that Cardiff could not reach its full potential as long as its sea trade was reliant upon a lock two kilometres from the open sea and capable only of providing access to ships of under two hundred tons. William Crawshay, the owner of the Cyfarthfa Iron Company and the chief shareholder in the Glamorganshire Canal Company, was eager to enlarge the sea-lock and to create a deep channel between it and low water. However, as the marquess owned all the land surrounding the lock, such plans were feasible only with his cooperation. His commission to Green in 1828 was generally welcomed by the freighters, but a further seven years passed before dock excavation began, years in which the tonnage of iron carried to Cardiff by the Glamorganshire Canal increased from 89,000 to 119,000 and that of coal from some 80,000 to 155,000.

The delay embittered the freighters. At loggerheads with Crawshay and the Glamorganshire Canal Company, the marquess was also antagonistic towards John Guest of the Dowlais Iron Company, particularly over the renewal of the lease of the company's mineral land, which was part of the Bute estate. In 1841, Cardiff was linked to Merthyr by the Taff Vale Railway, a venture initiated by Guest, and the relationship between the railway and the dock proved a fruitful source of hostility. Thus, the marquess's plans for the port of Cardiff were conceived in an atmosphere of suspicion towards him amongst the industrialists for whose trade the dock was built, suspicion which persisted throughout the nineteenth century.

That the marquess should have delayed was not surprising. Indeed, what is surprising is that he undertook the dock building at all. It cost him £350,000, a huge outlay for a man of relatively modest means. In the 1830s, the net receipts of his Glamorgan estate were some £4,000 a year and the returns from his largely rural Scottish properties were hardly greater. To finance the dock, he restored to large-scale mortgaging, mainly with the Equitable Assurance Society and, until the mid-1840s, his mortgage payments were considerably higher than his net

income. In Glamorgan, he was very much an absentee landlord, spending only a few weeks a year at Cardiff. His favourite residence was Mountstuart House on the Isle of Bute, from where he conducted an industrial revolution in Wales by correspondence. The correspondence was dictated by him for, being myopic, he was incapable of writing a legible letter. When he decided upon the dock project, he had no descendants and, in view of the ill health of his wife, was unlikely to have any. (She died in 1841, and the marquess remarried in 1845.) The heir to the marquessate was his brother, Lord James Crichton Stuart, a Whig against whom the marquess successfully sponsored a Conservative candidate in the general election of 1832.

Despite these disincentives, dock-building began in earnest in 1835. The dock was opened on 8 October 1839. It was a disappointing day for the marquess, an eyewitness reporting that 'the entire channel had been swept with a view to inducing a few big ships to enter [the dock] to add to the prestige of the occasion. Only one old wooden ship, one tug boat and the Bristol steamer was the whole flotilla.' In the first three months of the dock's operation, its entire trade amounted to a meagre eight thousand tons, a figure the marquess attributed to a 'combination of iron-masters and coalowners intent upon ruining me'. He proceeded to coerce the freighters, halting improvements to the sea-lock, evicting wharf tenants, encouraging the use of the port by ships too large to enter the canal's sea-lock and threatening to refuse to lease his mineral land to industrialists who did not use his dock. Although the freighters sought to retaliate by raising the possibility of building their own dock on the estuary of the Ely, the marquess had won by 1845 when the trade of the dock, then standing at 490,000 tons, exceeded that of the Glamorganshire Canal sea-lock for the first time.

The main part of the first of the Bute docks is no longer visible. In the early 1970s, it was filled in, using mainly material from the tip at Aber-fan – the spoil of an industry being used to obliterate the transport undertaking which had given it birth. Its site, immediately east of Bute St, is now known as Atlantic Wharf and contains suitably nautical places such as Schooner Way and Brigantine Place. The dock's basin and its entrance lock were not obliterated. Indeed, they were adapted in 2001 to provide the attractive public space known as the Oval Basin.

Other surviving structures of the first era of dock-building include the station of the Taff Vale Railway. One of the world's earliest railway buildings still standing, it was built in 1843 and represented a partial reconciliation between the 'Bute' and the 'Taff' concerns. They also include the ponderous neo-Romanesque church of St Mary, erected at the expense of the second marquess of Bute as a replacement for the church which the Taff had undermined centuries earlier. It was completed in 1845 and was intended as the focal point of the upper part of that other Cardiff which, to the marquess's delight, came to be known as Butetown.

The marquess enthused over every feature of his eponymous town. He corresponded obsessively concerning the building of St Mary's; he oversaw the erection of houses for key dock workers in Bute Crescent; he litigated over his right to insist that Bute Street, his great processional way, should be flanked by dignified buildings; he ensured that the layout of central Butetown was focused upon two squares – Mountstuart Square, named after his ancestral home, and Loudoun Square, named after the ancestral home of his second wife. 'The cornices at Loudoun Square', a Bute official proudly announced, 'are to be made with Roman cement as used in Belgravia.'

Many of the marquess's hopes were soon to be dashed. The boggy land of the moors caused drainage problems which contributed to the cholera epidemic of 1848. The need to provide affordable housing for dock-workers led to the erection of what George Santayana described as 'rows of mean little brick houses all alike', creating a townscape where 'ugliness and desolation could not be more constitutional'. Above all, Butetown rapidly developed an unsavoury reputation. In 1852, four years after the marquess's death, it was denounced as 'increasingly vile and abominable . . . Keepers of public houses and brothels are gradually obtaining possession of the whole [area] . . . Cardiff is gaining a worldwide reputation as one of the most immoral of seaports.'

By 1853, the trade of the dock had risen to 1.12 million tons, an increase of 630,000 tons in eight years. Cardiff was becoming suffocated by congestion. In his reminiscences of the 1850s, W. J. Trounce recalled seeing American clippers, Dutch East Indian ships and French long couriers being diverted from Cardiff.

'I have known', he wrote, 'vessels detained for a week and sometimes longer in the Penarth Roads, awaiting their turn to come into dock.' In 1852, the third marquess's trustees committed themselves to construct a second dock – the East Bute Dock – which was completed in 1859.

With the Bute estate making such a massive investment, an assumption arose that, but for its contribution, Cardiff would not have prospered so mightily as a port. Yet, there was an inevitability about its growth. As it lies on the estuary of the river which drains the richest part of the south Wales coalfield, it would, even without the Bute initiatives, have experienced marked expansion as the riches of the Taff, Cynon and Rhondda valleys were increasingly exploited. Indeed, there were those who argued that the docks' narrow ownership base greatly retarded their progress. The uneasy relationship between the estate and the freighters made for disharmony. After the East Dock had been completed, Parliament refused to permit any further expansion on the grounds that the owner of the docks was a minor and therefore could not be consulted. On reaching adulthood, the third marquess, an inveterate traveller and something of a religious mystic, showed little interest in modern industry and preferred to spend his money on restoring medieval buildings rather than on building docks.

Yet, there can be no doubt that, initially at least, the Bute contribution was of crucial importance. In 1830, Cardiff's coal exports were exceeded tenfold by those of Newport and fourfold by those of Swansea. Newport acquired a masonry dock in 1842, but it was less than a quarter the size of that opened at Cardiff in 1839. Swansea would not have a substantial dock until 1859, a year in which Cardiff's coal exports were thrice those of Swansea and twice those of Newport. Furthermore, as the leading landowner in upland east Glamorgan, the Bute family was in a position to oblige industrialists leasing its coal seams to export their output at Cardiff. In addition, Bute officials were able to influence the layout of railways, thus considerably expanding the area linked to Cardiff – spectacularly so in the case of the Rhymni Valley.

In 1859, with the completion of the East Bute Dock, Cardiff handled 1.868 million tons of exports and imports, a figure which rose to 3.588 million in 1874, when a minor addition to

Coal Exports and the Total Trade at the Bute Docks, 1839–1888

	Tonnage coal exports (including coke and patent fuel)	Tonnage of total trade (exports and imports)
1839	6,500	8,282
1840	43,651	46,042
1841	87,170	117,639
1842	196,259	239,897
1843	210,655	268,139
1844	258,072	278,989
1845	359,755	490,035
1846	420,281	565,934
1847	441,073	615,544
1848	619,226	778,974
1849	635,115	827,134
1850	661,382	873,413
1851	707,520	918,336
1852	801,697	1,051,739
1853	834,221	1,120,566
1854	1,051,748	1,331,456
1855	1,084,536	1,323,868
1856	1,327,660	1,609,078
1857	1,440,679	1,757,911
1858	1,259,126	1,596,733
1859	1,511,351	1,868,498
1860	1,802,450	2,225,980
1861	1,915,120	2,329,649
1862	2,097,766	2,542,194
1863	2,239,331	2,724,627
1864	2,131,326	2,642,268
1865	2,269,705	2,832,248
1866	2,362,650	2,876,803
1867	2,340,826	2,851,563
1868	2,449,639	2,972,138
1869	2,184,759	2,813,501
1870	2,183,818	2,804,798
1871	1,944,498	2,658,362
1872	2,587,339	3,523,060
1873	2,516,606	3,431,712
1874	2,680,199	3,588,913
1875	2,896,609	3,635,757
1876	3,620,364	4,402,453
1877	4,094,129	5,002,140

	Tonnage coal exports (including coke and patent fuel)	Tonnage of total trade (exports and imports)
1878	4,259,984	5,150,437
1879	4,465,797	5,449,955
1880	5,006,611	6,291,137
1881	5,413,125	6,607,891
1882	5,842,538	7,241,404
1883	6,746,664	8,214,802
1884	7,006,558	8,316,801
1885	6,911,259	8,111,052
1886	6,749,851	8,001,588
1887	7,116,681	8,393,832
1888	7,829,626	9,268,802

Source: Cardiff City Library, Bute Collection XI, 56.

the port's capacity, the Roath Basin, was opened. Thereafter, thirteen years went by before there was any further expansion, years during which the trade of the Bute docks increased from 3.588 to 8.393 million tons. The resultant congestion obliged the Bute authorities to commission the Roath Dock which was opened in 1887. On the eve of the opening, the tonnage per acre handled at Cardiff was the highest in the world, and it was possible to walk across the docks by stepping from deck to deck of the vessels moored within them.

What can now be seen of the east dock is the reverse of what can be seen of the west dock. At the west dock, the basin and the dock entrance survive but the dock itself has been obliterated. At the east dock, the basin and most of the entrance lock have been obliterated but the dock itself survives. It is now a tranquil lake, the banks of which are graced by a pagoda-like building. That was erected in 1987 as the South Glamorgan County Hall, and is now the administrative centre of the city and county of Cardiff. The Roath Basin is but a shadow of what it was in its heyday for, instead of accommodating ocean-going vessels, it now provides a mooring place for a little lightship which floats serenely among the surrounding jellyfish. The area between the Roath Basin and the eastern dock's lock entrance was once covered by sidings crammed with trucks loaded with coal awaiting export. It is now

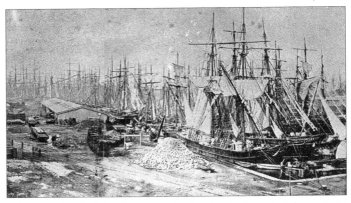

The Bute West Dock in about 1870 showing the closely packed ships waiting to be loaded with coal. Although steam tonnage registered at Lloyds had exceeded sail tonnage by 1865, the vast majority of vessels entering the Bute Docks in the 1870s were sailing ships.

the site of large office buildings, among them Crickhowell House, the present but – it is to be hoped – not the permanent home of the National Assembly for Wales. Beyond the Roath Basin lies the Roath Dock, where visits by sightseers are discouraged. The original access to the basin and on to the dock has been blocked, but vessels can still enter the dock via the channel linking it to the Queen Alexandra Dock, opened in 1907.

It was in the years between the completion of the East Bute Dock (1859) and the Roath Dock (1887) that the characteristics of Cardiff as a commercial centre became clearly defined. The town was concerned almost exclusively with transport for, despite the superabundant availability of coal and metals, the Cardiff of the 1860s, 1870s and 1880s failed to establish a more varied economic base. Although the town was to acquire a major steelworks in the 1890s, the only industries developed in the three previous crucial decades were those ancillary to the town's central activity – the movement of goods by rail and ship. Cardiff's inability to acquire the diversity achieved in places such as Clydeside and Tyneside is an issue of much debate. It has been suggested that the town's development occurred too late for it to compete effectively with regions where the necessary skills were already well established.

But perhaps the key explanation is that offered in 1904 by a local journalist who argued that local businessmen had given their 'attention to the local staple, and may not be seduced into a consideration of anything else . . . For the matter of that, [they are] making a sufficiently good thing of it.'

As Cardiff's leading businessmen had no permanent investment in the town, using it merely as a centre for the movement of goods, they lacked that rooted concern for the local community which characterized factory owners in places such as Birmingham and Manchester. Furthermore, Cardiff's rapid growth meant that virtually none of the town's capitalists were Cardiff-born, a fact which further detached them from their place of residence. That detachment is apparent in the general non-involvement of members of Cardiff's mercantile elite in local philanthropic causes and in their reluctance to seek election to the Cardiff Corporation. Thus, Cardiff's educational institutions did not benefit from the gifts of local plutocrats as did the educational institutions of Manchester, and Cardiff did not provide a political role for industrial dynasties as did Birmingham with the Chamberlain family.

While a detached elite was one aspect of Cardiff as a commercial centre, a far more important feature was its reliance upon exports. Of the 490,000 tons handled by the West Bute Dock in 1845, only 3.1 per cent represented imports. The Bute authorities made strenuous efforts to increase imports, for ships carrying goods when both entering and leaving made two payments of dock dues, while those leaving with goods but entering in ballast paid only one. They had some success for, by 1880, imports had risen to 15.5 per cent of the trade of the docks. Yet, hopes that Cardiff would become a major centre for the import of the more profitable general merchandise never materialized, and the port's imports – mainly iron ore and pit props – merely underlined the docks' reliance upon the local staples.

It was as an iron-exporting centre that the port began its meteoric career. By 1830, however, coal exports had come to exceed iron exports, at least in tonnage terms. Yet, as iron is by weight far more valuable than coal, coal exports did not exceed iron exports in monetary terms until the mid-1850s. Even then, the buoyancy of Cardiff's trade in iron rails ensured that it

continued to be one of the world's chief iron-exporting ports. Rail exports declined in the early 1870s, and the huge coal boom of those years ushered in the fundamental characteristic of Cardiff's heyday as a port – the massive dominance of coal exports.

At first, the coal trade of Cardiff was almost exclusively with other British ports or with Ireland. (Ships carrying coal to Ireland usually entered Cardiff with limestone as ballast, which explains the fine stonework of Cardiff's older pavements.) In 1844, 93.5 per cent of Cardiff's coal shipments were conveyed to ports in the United Kingdom. Had that reliance continued, Cardiff would have gone into decline for, with the expansion of the railway network, it became cheaper to transport coal by rail rather than by ship. Foreign shipments first exceeded coastal shipments in 1854 and, by 1880, they had come to represent 85 per cent of Cardiff's coal trade. Initially, the foreign shipments went almost exclusively to the European mainland, but by the late nineteenth century, when Cardiff had won recognition as the world's greatest coal port, the entire world was a market for its coal. As Cardiff's coal trade came to embrace almost the entire planet, and particularly with the establishment of the coal stations of the Cardiff-based Cory Brothers at strategic places along international sea-lanes, the port became the focal point of a worldwide network, a marked contrast with other United Kingdom ports – Hull, for example, where contact was almost exclusively with Scandinavia and the Netherlands.

By the 1880s, Cardiff was handling 72 per cent of the coal exports of the south Wales coalfield, and such was the reputation of the port that coal conveyed from Cardiff commanded higher prices than identical coal shipped from other south Wales ports. The dozen or so countries producing a coal surplus exported a total of 61 million tons. Of that total, 62 per cent came from Britain. Cardiff's exports represented 29 per cent of Britain's exports and 18 per cent of the total world exports. As almost a fifth of the international trade in the source of heat and energy was shipped from Cardiff, the port in the 1880s occupied a position in the world economy comparable to that occupied by the Persian Gulf a century later. Such was the fame of the port that, when Eugene O'Neill wrote a play concerning heroism at sea, he chose as its title *Bound East for Cardiff*. In 1914, the Wharf

A photograph of a marshalling yard near the Roath Dock in 1927. By then, vast sidings with thousands of wagons laden with coal had been a feature of Cardiff for well over half a century.

Theatre in Provincetown, Massachusetts, rang to the words: 'You know Fanny, the barmaid at the Red Stork in Cardiff.'

The reliance upon foreign coal exports had profound implications for the citizens of Cardiff. It had a marked impact upon the environment, for the need to find places to stockpile so bulky a commodity meant that vast sidings for trucks were necessary. These became a feature not only of Butetown but also of parts of Cathays and of outlying villages such as Radyr. Shipping the coal created a demand at Butetown for coal trimmers, crane drivers and other jobs relating to vessel-loading. Conveying it to Cardiff and storing it there greatly expanded the need for railway workers, and Cathays was developed as Cardiff's railway suburb. The dockworkers and the railwaymen constituted the core of Cardiff's working class, and the rise in the demand for their labour was the fundamental reason for the fourfold increase in the town's population between the mid-1850s and the mid-1880s.

The fact that imports were a minor feature of Cardiff's trade meant that fully laden ships entering the docks and paying off an entire crew there represented only an occasional feature of the

65

life of the port. More common was a ship with a skeleton crew entering in ballast, with its captain having, on seeking a full crew at Cardiff, a choice of seamen who had come there after spending their paying-off money at other ports. As a place of embarkation rather than arrival, Cardiff was a 'hard-up' port, a fact reflected in the impoverished boarding houses and the poor facilities of Butetown. The penniless seamen who arrived at the docks were often obliged to accept any work offered to them. This made them unlikely members of a trade union, a cause of concern to Havelock Wilson, the secretary of the seamen's union, who described Cardiff as 'the most undesirable port in the United Kingdom'.

With Cardiff so overwhelmingly concerned with a single product, its trade developed a character wholly different from that of places such as Liverpool and Glasgow, with their diverse range of imports and exports. As E. L. Chappell put it: 'Few seaports of the magnitude of Cardiff have . . . developed in so lopsided a fashion.' The reliance on coal made the Bute Docks highly vulnerable to any downturn in the demand for it, a fact which became painfully apparent in the inter-war years. As the port and its hinterland were geared to international trade rather than to the internal rhythms of the British economy, the business cycles of Cardiff, and indeed those of the south Wales coalfield as a whole, were often different from those of the state of which they were part.

The percentage increase in Cardiff's coal exports was 21 in the 1860s, 129 in the 1870s and 59 in the 1880s. Thereafter, there was no major advance. That was the result of the establishment of a rival dock system. In 1883, some of Cardiff's leading freighters submitted to Parliament a bill seeking authorization to construct a dock at Barry and a railway linking it to the coalfield. The decision was motivated by two factors already mentioned: the freighters' mistrust of the Bute estate and their lack of allegiance to Cardiff. Much of their criticism of the Bute Docks was baseless. Charges there were not exorbitant, and the vast profits which the marquess was reputed to draw from them were a myth. Although there was congestion, the Bute authorities had obtained parliamentary sanction for a new dock in 1882, a year before the submission of the Barry bill. The real point at issue was the freighters' desire to have a complex of docks under their

own unfettered control, and it mattered little to them if Cardiff suffered as a result. Indeed, Barry's main promoter, the coalowner, David Davies, prophesied with some gloating that Barry's success would cause grass to grow in the streets of Cardiff. (It should be acknowledged that his granddaughters, by presenting the National Museum with its superb collection of the work of the French Impressionists, did something to compensate for their grandfather's malevolence towards Cardiff.)

The Barry bill was passed in 1884 after one of the most protracted battles in the history of Parliament. The Barry dock and railway were opened in 1889. Cardiff's monopoly of the coal trade of the Taff basin had been breached before, with the opening of the Taff Vale Railway Company's Penarth Dock in 1864. Penarth came to handle up to a quarter of the coal exports of the Taff basin, but it aroused no enthusiasm among its sponsoring company's directors. 'The undertaking', declared the Taff chairman in 1880, 'has always been a sort of incubus upon the company.' The Barry enterprise proved to be a far greater challenge, for it had advantages not enjoyed by the Bute Docks. It was not an estuary port and therefore did not have the costs of scouring a channel to the open sea. As a new concern, it was not burdened with redundant investment as was the case in Cardiff, where the East and West Docks were, by the 1880s, virtually unusable by newer ships. Unlike Cardiff, Barry was an integrated enterprise including not only a dock but also the railway tracks which supplied the dock with coal.

Barry's advantages soon became apparent. In 1891, two years after its completion, it exported 3.959 million tons of coal. By 1901, Barry had replaced Cardiff as the world's leading coal port, a fact which is not readily apparent for, in most statistical tables, Barry's figures, together with those of Penarth, are generally combined with those of the Bute Docks and presented as the figures of the Port of Cardiff. Yet, so rapid was the growth in the output of the south Wales coalfield that the rise of Barry did not lead to a fall in the coal exports of the Bute Docks. Indeed, the need to justify the existence of two large complexes of docks serving the central valleys of the south Wales coalfield helped to propel the coal output of those valleys to unsustainable levels – the context of the appalling disaster which befell the coalfield in the 1920s. But, although there was no decline in

The coal exports of the Bute Docks, the Barry Docks and Penarth Dock and the total coal exports of the Port of Cardiff, 1889–1914

	The Bute Docks	Barry Docks	Penarth Docks	Port of Cardiff
1889	7,735,536	1,073,575	2,776,712	11,585,823
1890	7,420,080	3,192,691	1,566,599	12,179,370
1891	6,949,424	3,959,621	1,940,117	12,849,162
1892	7,323,095	4,191,074	2,079,483	13,593,652
1893	6,725,320	4,211,822	2,133,284	13,070,426
1894	7,668,606	4,896,822	2,429,408	14,994,836
1895	7,542,220	5,051,832	2,507,913	15,101,965
1896	7,690,205	5,279,232	2,818,368	15,787,805
1897	7,722,995	5,854,920	3,051,743	16,629,658
1898	5,652,666	4,369,448	1,953,263	11,975,377
1899	8,279,005	7,223,369	3,368,209	18,870,583
1900	7,549,312	7,225,599	3,253,257	18,028,168
1901	7,216,311	7,844,464	3,467,846	18,528,621
1902	7,090,291	8,675,475	3,599,382	19,365,148
1903	7,169,912	8,840,891	3,800,230	19,811,033
1904	7,490,481	9,113,762	3,871,226	20,475,469
1905	7,294,020	8,651,511	3,740,061	19,685,592
1906	7,935,490	9,730,588	4,229,594	21,895,672
1907	8,909,823	9,883,096	4,569,989	23,362,908
1908	9,017,603	9,732,007	4,267,582	23,017,192
1909	9,614,950	10,047,370	3,916,760	23,579,080
1910	9,501,960	9,623,499	3,966,096	23,091,555
1911	9,320,656	9,145,788	3,979,410	22,445,854
1912	9,601,648	9,728,319	4,179,506	23,509,473
1913	10,576,506	11,049,711	4,513,117	26,139,334
1914	10,278,963	10,875,510	3,992,405	25,146,878

Sources: Cardiff City Library Bute Papers XI, 56; *Annual Reports*, Cardiff Chamber of Commerce.

Cardiff's coal exports, there was nothing comparable with the dramatic increases of previous decades. With coal exports virtually static, Cardiff's population growth slowed down markedly – from the 57 per cent of the 1880s to the 28 per cent of the 1890s and the 11 per cent of the 1900s.

The Bute authorities made valiant attempts to compete with Barry, particularly by seeking to increase Cardiff's imports, an almost negligible feature of Barry's trade. Barry obtained parliamentary permission to build another dock in 1893, as did Cardiff in 1894. The building of Cardiff's new dock, which involved taking over 130 hectares of the seabed, proved to be a lengthy business. Named the Queen Alexandra Dock, it was not completed until 1907, when it was hailed as the largest masonry dock in the world. The Bute authorities came to the conclusion that, to compete effectively with Barry, they too needed their own railway to the coalfield. The Cardiff Railway reached the coalfield in 1911 but, as its coal traffic consisted merely of what its rivals chose to divert to it, its completion led to no discernible rise in the receipts of the Bute Docks.

The failure of the railway project was symptomatic of the dire financial history of the docks from the 1890s onwards. According to the Bute auditor, every new investment was 'a measure of defence . . . imposed upon the owners . . . not so much to enhance as to maintain the value of the property'. In 1886, with the establishment of the Bute Docks Company, the docks ceased to be solely owned by the marquess of Bute. (The company was renamed the Cardiff Railway Company in 1897.) It rarely paid an annual dividend of more than 1 per cent, and frequently paid no dividend at all. To avoid collapse, it was obliged to exploit its chief shareholders – the third and, from 1900, the fourth marquesses of Bute. (The real wealth of the Butes came from ground rents and mineral royalties, money they would have received even if others had undertaken the dock-building.) When the Cardiff Railway Company was acquired by the Great Western Railway Company in 1922, its shareholders' nominal investment of £7,325,000 was exchanged for GWR shares worth £3,502,000.

Many of the company's troubles were attributable to competition from Barry. Yet, despite the fact that the rise of Barry resulted in the virtual cessation of growth in the coal trade of the

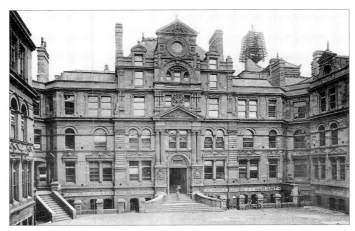

Cardiff's Coal and Shipping Exchange. Designed by Edwin Seward, it was erected between 1884 and 1888. Agreements made on its trading floor determined the price of coal on the British and international markets.

Bute Docks, Barry's success helped to consolidate Cardiff's position as the centre of the world's coal trade. Although more coal came to be shipped at Barry than at Cardiff, all the associated financial, legal and secretarial work was carried out at Cardiff, for no shipowner or coalowner relocated to Barry. Thus, the increase in the coal, coke and patent fuel exports of the Port of Cardiff as a whole – from 12.179 million tons in 1890 to 26.139 million in 1913 – meant a significant increase in commercial activity at Cardiff. It was an increase which helped to confirm Cardiff's place at the apex of the urban hierarchy of south Wales.

The chief monument to Cardiff's pre-eminence is the Coal and Shipping Exchange. It was inaugurated in 1886 and occupies Mountstuart Square which, until its construction, was an open space. Before the establishment of the Exchange, coal merchants chalked up the changing prices of coal on slates outside their offices or struck deals in the local public houses. Following its opening, coalowners, shipowners and their agents met daily on the floor of the trading hall where agreements were made by word of mouth and where that novelty, the telephone, was avail-

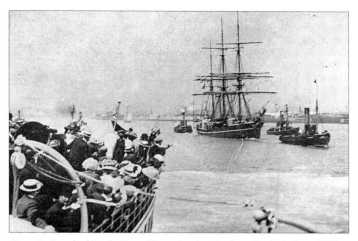

Captain Scott's ship, the Terra Nova, *leaving the Bute Docks in June 1910.*

able. During the peak trading hour of midday to one o'clock, the floor might accommodate as many as two hundred men gesticulating and shouting, a scene which amazed the spectators in the gallery. There was much excitement in 1907 when the world's first million-pound deal was struck at the Exchange, and further excitement in 1912 when the refurbished hall, rich in oak panels and Corinthian columns, was opened and when one of the lavish dinners beloved of Cardiff's plutocrats was consumed. There was a more melancholy event there in July 1913 – the welcome to the crew of the *Terra Nova*, the ship which three years earlier had sailed from Cardiff carrying Captain Scott and his team on their ill-fated expedition to the Antarctic. A plaque at the Exchange commemorating the occasion notes that 'without the assistance given by Cardiff, this expedition would not have been possible'.

Those seeking the evidence which survives of Cardiff's glory days as the world's coal capital should make their way to Mountstuart's non-existent square. There the Exchange building still looms. Its ponderousness is not without appeal, but the concrete ramp and the access to its underground carpark have spoiled its main façade. (It is gratifying to hear that these accretions are soon to be removed.) Those ugly features were installed in the 1970s,

The coat-of-arms on the Pierhead Building.

when Butetown's fortunes were reaching their nadir and when the building's owners were desperate to ensure that the building had some sort of future. It appears that it was the local MP, James Callaghan, the prime minister, who suggested in 1977 that the Exchange should become the home of the Welsh Assembly. The referendum vote of 1979 put paid to that inspired idea. In 1982, there were hopes that it would house the offices of the Welsh-language television channel (S4C), a notion which arose from the fact that the beginnings of Butetown's regeneration owed much to the independent television companies which settled there. That did not come about either but, with regeneration now gathering pace, the building's owners are surely destined eventually to gain rich rewards.

The Exchange should be the starting-point of a perambulation of the coal metropolis. Explorers will become aware that the place Cardiff's merchant princes dismissively called Uptown – the historic town centre – was in the late nineteenth and early twentieth centuries a parasite drawing its life from this merchant city. Uptown had modest banks, adequate for the needs of small retailers. The merchant city had banking palaces, the most magnificent of which – the National and Provincial Bank at 113–16 Bute Street – was completed in 1927 when everything was coming to an end. Opulent banks were cheek by jowl with opulent offices – Baltic House, Ocean Buildings, Cory's Buildings, Cambrian Buildings – some of which have fascinating motifs well worth examination. But just as the Butes triumphed in Uptown with their astonishing castle, so also did they triumph here with their delightful Pierhead Building. Completed in 1897 and designed by William Frame, its profile and its red-hot brick

and terracotta make it instantly recognizable. Built as the head-quarters of the Bute-founded Cardiff Railway Company, the coat of arms emblazoned on its façade bears the company's motto *Wrth Ddŵr a Thân* (by fire and water), and thus encapsulates the elements creating the steam power which transformed Wales. The building now houses the National Assembly's Information Centre for, sadly, the idea that it should be the office of Wales's chief minister – an idea rich in symbolism – has not been acted upon.

None of the merchant princes lived in Butetown, preferring villas at Penarth or Llandaff, or mansions in the Vale of Glamorgan or further afield. Few of the office workers lived there either, opting instead for houses in the more salubrious suburbs. Butetown had a largely working-class population, inhabiting an area some 1,800 metres from north to south and between 150 and 500 metres from west to east. Its inhabitants were hemmed in on the north by the railway embankment, on the east by the docks, on the west by the Glamorganshire Canal, and on the south by the estuary and its diverse ship-repairing yards and dry docks. The district of banks and offices was small, consisting of a triangle with its corners at Bute Crescent, Mountstuart Square and the Bute Road Railway Station. To the south lay the streets which Butetown inhabitants called 'down the docks', although that part lying between the canal and the Taff was known as Rat Island. In 1866, an old Spanish frigate, the *Hamadryad*, was moored near the entrance of the canal and used as a hospital ship. It was replaced by a building, the Royal Hamadryad Hospital, in 1896. Rat Island became Butetown's middle-class enclave, with pilots and ships' masters occupying the substantial dwellings of Clarence Embankment and Windsor Esplanade, where houses now change hands at up to £250,000.

It was the area north of the bank and office district which came to epitomize Butetown. The community that developed there, in a rectangular area bounded on the north and south by Greek Church Street and Loudoun Square, and on the east and west by Bute Street and the Glamorganshire Canal, was that of Tiger Bay, called perhaps after *A bahia de los tigres*, the name give by Portuguese seamen to the choppy waters leading to the Bute Docks. (In fact, Tiger Bay does not at any point adjoin the sea; those from 'down the docks' who went there on a visit,

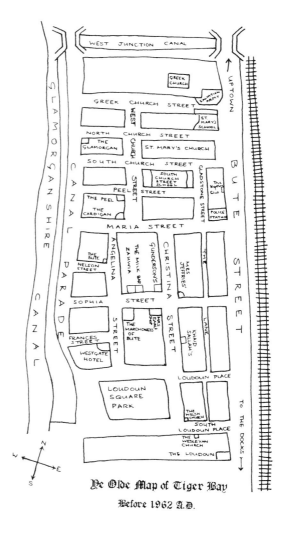

Neil Sinclair's map of Tiger Bay.

74

talked of going 'up the bay'.) Tiger Bay's renown is the result of its rich racial mix and the high degree of relaxed cosmopolitanism which evolved there. Migrants from Aden, the Caribbean, West Africa, India, Hong Kong and elsewhere were part of the Butetown society as early as the 1880s. As Neil Sinclair put it in his fascinating reminiscences: 'You could see the world in one square mile.'

By 1911, Cardiff was second only to London among British cities in its proportion of foreign-born inhabitants. Yet, in that year, Butetown's permanent coloured community was small, consisting of perhaps no more than seven hundred people. Transient coloured men seeking employment as crew members were more numerous. They were resented by white sailors, who believed that they were being used to keep down wages – the context of the anti-Chinese riot at Cardiff during the seamen's strike of 1911.

The First World War had a traumatic impact upon the Butetown community. With coal being commandeered by the Admiralty, the tonnage handled by the Bute Docks declined by 36 per cent between 1914 and 1918. Nevertheless, with merchant seamen joining the Royal Navy, there was an increased demand for crew members, many of whom were recruited from distant parts of the British Empire. Some of them settled at Cardiff; they found wives in the local community, giving rise to psychosexual fantasies among elements of the city's white population. They bought houses, causing the coloured community to extend beyond the boundaries of Tiger Bay. Although at least a thousand coloured seamen sailing from Cardiff lost their lives during the war, there was among the white population a perception that it was the whites who had borne the brunt of the sacrifice. With the end of the war, large numbers of demobilized sailors found themselves unemployed.

These factors were the sparks which ignited the race riots of 11 to 13 June 1919, which left three men dead, dozens injured, and caused extensive damage to property. Almost all the violent incidents occurred to the north of Butetown. It was an area of new coloured settlement and, as a consequence of the riots, Cardiff's coloured population was driven back to Tiger Bay. Over the following decades, the Bay became Britain's closest approximation to a ghetto. Indeed, fifty years after the riots,

there was still a perception that the district north of the railway bridge was a no-go area for its inhabitants. Tiger Bay represented security. It was, to quote Sinclair, 'the safest haven in Britain for men of colour', a fact underlined during the Second World War when black American servicemen from all over Britain spent their leisure hours there to avoid the racism of American camps. Its most remarkable feature was the wide-ranging origins of its community's members, representing as they did some fifty different ethnic groups. Most of them were of partially white descent, for female coloured immigrants were rare in Cardiff until the 1950s. To Sinclair, the Bay was a place where 'Welsh women were heads of household of Third World men', and their descendants were Indo-Cymric and Afro-Celtic. 'We', he wrote, 'are an indelible and recognizable part of Welsh history.'

Despite the tensions of the immediate post-war years, those years were a period of boom in the history of the Bute Docks. With the countries of mainland Europe – France in particular – desperate to reconstruct their economies, there was a huge demand for coal and a readiness to pay up to six pounds a ton for it, five times the price in 1914. The demand led to an astonishing increase in the number of shipping companies at Cardiff – up from 57 in 1919 to a 150 in 1920. By then, when five hundred vessels with a total capacity of two million tons were registered there, Cardiff was the greatest tramp-steamship-owning centre in the world. Money poured in, and the merchant princes of the docks, eager for honours, won for Cardiff the title of 'the city of the dreadful knights'.

The boom was short-lived. By 1921, the value of Cardiff's shipping fleet was a fifth of what it had been a year earlier, and a number of the city's plutocrats had slipped into bankruptcy. The following year saw the end of the ownership of the docks by the Bute-created Cardiff Railway Company. On 1 January 1922, that company, together with the Barry, the Taff and the Rhymney concerns, became part of the Great Western Railway Company. The new management enjoyed a brief period of prosperity, for the coal exports of the Port of Cardiff reached their apogee in 1923. Thereafter, however, decline was inexorable. In 1936, the total trade of Cardiff Docks was 6.4 million tons, compared with 13.6 million in 1913. Cardiff's entire reason

W. J. Tatem, 1868–1942

W. J. Tatem was the richest of the Cardiffians given an honour during the premiership of Lloyd George (1916–22). A native of Devon, he established himself in Cardiff where he founded the Tatem Steam Navigation Company and became a director of most of the shipping companies operating from the Bute Docks. He was high sheriff of Glamorgan, chairman of the Cardiff Shipowners' Association, president of University College, Cardiff, and president of the Royal Porthcawl Golf Club. A buccaneering figure, his favourite saying was: 'If you've got it, flaunt it.' In 1919, he entered two horses in the Derby. He vaunted the merits of one, Dominion, on which the odds were 100–9. He kept quiet about the other, Grand Parade, which won the race at 33–1, with Tatem himself virtually the only person to put money on it. On 18 June 1918, he was ennobled as Baron Glanely of St Fagans. According to local legend, he paid £50,000 for the honour, presenting a cheque to one of the organizers of Lloyd George's political fund. The story goes that the following conversation ensued:

Organizer: 'Isn't your name W. J. Tatem?'

Tatem: 'Yes.'

Organizer: 'Then why is this cheque signed Glanely?'

Tatem: 'Because my name is going to be Lord Glanely and, if it isn't, you won't be able to cash that cheque.'

for existence seemed to be vanishing. The demand for dock and railway labour collapsed. Unemployment soared, reaching a peak among the city's adult insured males of 36.2 per cent in January 1933 – a favourable figure, admittedly, compared with the 74 per cent at Ferndale and the 70 per cent at Merthyr.

Matters improved in the mid-1930s and by August 1939, the last month of peace, unemployment at Cardiff had fallen to 13.3 per cent. During the war, it fell virtually to zero. The docks underwent a revival. As they were on the western, safer, side of Britain, they were extensively used for the import of strategic material from the United States. There was an inexhaustible demand for the services of Cardiff's shipping companies,

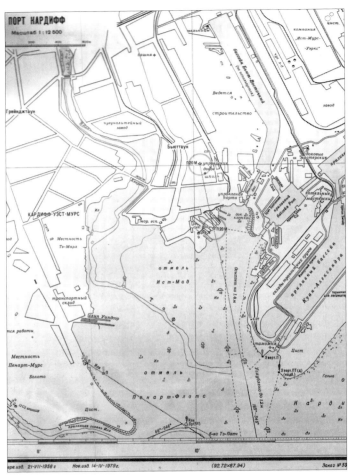

A Russian-language map of Cardiff Docks, published in 1979. That the Russians were interested in Cardiff was not an indication of an impending Soviet invasion. The map was used by ships from the USSR transporting scrap iron to Cardiff, a significant element in the trade of the docks in the 1970s.

although several, Reardon Smith and Evan Thomas, Radcliffe among them, lost the bulk of their vessels to torpedoes. With the East Moors Steelworks working to full capacity, many of Butetown's previously idle dock and railway workers found employment there. Curran's, the engineering company situated between the Taff and the canal, flourished greatly and had thirteen thousand workers on its payroll by 1944. Although Bute Street was bombed in January 1941, the dock area suffered less from air raids than did other Cardiff districts such as Grangetown and Riverside.

With the end of the war, the problems apparent in the 1930s returned. The docks, which, following the nationalization of the railways, eventually came under the control of British Associated Ports, went into further decline. The Coal Exchange closed in 1958 and coal exports came to an end in 1964, when the total trade of the docks was a mere 2.9 million tons. Butetown, wrote a *Guardian* correspondent in the mid-1960s, 'is the most tranquil and evocative commercial centre in Europe'. With its mercantile palaces virtually unrentable, there were mutterings that the best it could hope for would be a decent funeral.

The corporation's first concern was to improve working-class housing, and a major redevelopment scheme was launched in the late 1950s. It involved the virtual demolition of Loudoun Square, whose former attractions are now only visible to those viewing the film *Tiger Bay*, produced in 1959. In Adamsdown, Riverside and elsewhere, the corporation sought to refurbish the existing houses. This was not its policy in Butetown, where the preferred option was the destruction of low-rise streets and their replacement with tower blocks. Thus was the community of Tiger Bay broken up, and that, it was widely believed, was the result of official malevolence towards it. Obituaries to the community are legion and include the sardonic comment of Olwen Watkins: 'When you've got an established community and you redevelop it, you might as well have dropped a bomb on it because it will never be the same again.' 'Who', asked Neil Sinclair, 'was the unknown architect whose dream created our nightmare?'

Demolition also seemed to be facing the commercial enterprises of Butetown. The West Bute Dock was filled in, as were the openings of the East Bute and Roath Docks. Imperial

79

Buildings and Gloucester Chambers were pulled down and the Customs House was boarded up. The Norwegian Church and that one-time temple of gastronomy, the Big Windsor Hotel, became dilapidated. Hopes of radical change in the wake of the establishment of the Welsh Assembly were dashed in 1979. Butetown came increasingly to be seen as Cardiff's withered arm.

Salvation – if indeed it will be salvation – is now believed to lie with the Cardiff Bay Development Scheme, inaugurated in 1987. The scheme envisaged a freshwater lake held back by a barrage and occupying the estuaries of the Taff and Ely rivers. It was essentially the brainchild of Nicholas Edwards, secretary of state for Wales from 1979 to 1987 who, to quote Rhodri Morgan, had 'watery ambitions to be the new Marquess of Bute at the taxpayer's expense'. A tour of the new Butetown should start at the 1.7-kilometre barrage completed in 2001. A remarkable engineering feat, it encloses a 200-hectare lake, provides thirteen kilometres of waterfront and contains the largest fish-pass in Europe. From the barrage, a waterbus sails to the shopping centre of Mermaid Quay, which stands on the site previously occupied by the Welsh Industrial and Maritime Museum. (The museum will eventually be relocated at Swansea, part of the trade-off between the two cities following Swansea's failure to secure the National Assembly.)

From Mermaid Quay, explorers should make their way to National Techniquest, a fascinating science exhibition centre, and then on to Clarence Bridge to view the site of what was the Curran Engineering works. It is now being replaced by luxury flats, a further episode in the de-industrialization of Butetown. The bridge offers a view of the five-star St David's Hotel, described by one of its many critics as a 'block of flats dressed up as a nun'. The walk up Bute Street allows the explorer to experience the redevelopment of Tiger Bay. Bute Street leads to Tyndall Street, the site of the Bute warehouse built in 1861. An astonishingly modernistic building for its time, it was skilfully converted into offices in 1987. Tyndall Street provides access to Lloyd George Avenue, the processional way to Cardiff Bay completed in 2001.

At the avenue's southern end, sightseers should try to brazen their way to Cargo and Longships Roads to appreciate the size and the inactivity of the Queen Alexandra Dock. (British Associ-

ated Ports sacked all its employees at Cardiff in 1990.) Near the dock is the Cardiff Bay Visitors' Centre, a lengthy tube on stilts where a display enthuses about *The Spirit of Cardiff*, a ship which is attempting to capture the world record for sailing around the world. Adjoining the centre are vast building sites, which can cause any description of Butetown to be almost immediately out of date. Even after only a few months' absence, visitors can feel bewildered by what seems to them to be a wholly unrecognizable townscape.

The building sites include a hole in the ground which may – or may not – represent the foundations of the permanent home of the National Assembly. The doubt arises because the execution of the Cardiff Bay scheme has been characterized by fits of indecision, among them the 1994 débâcle concerning Zaha Hadid's design for an opera house and the 2001 ditherings over Richard Rogers's design for the Assembly chamber. Other question marks hang over the Cardiff Bay development. Will the lake eventually be a nauseous pool of poisoned water? Will the enterprises locating at the Bay ever attain that critical mass which will permit a take-off to sustained economic growth? Will development leave any space at all for what remains of Butetown's multi-ethnic community? Does the de-industrialization of Butetown mean that the much-hyped 'most exciting waterfront development in Europe' will result in a middle-class enclave divorced from the meaning of Butetown's history?

The place to ponder these questions is the Norwegian Church, re-erected in 1992 at the edge of the Roath Basin. It may be fitting for explorers to sit quietly in the nave, there to hope and pray that this thing will succeed.

4 Outer Cardiff

Guides to cities rarely tell the traveller anything about the periphery. Works on Florence, for example, are reluctant to inform the visitor that around the wonderful historic centre, there are swathes of built-up areas offering little of interest even to the most dedicated tourist. Cardiff is luckier, for those venturing beyond the old parishes of St John and St Mary to explore the districts which have been brought within the boundaries of the city will find much to delight them. Borough enlargement has proved to be a protracted process, for Cardiff's boundaries were extended in 1875, 1922, 1938, 1951, 1974 and 1996. In the process, Cardiff increased in area from the 786 hectares of the original two parishes to the 13,953 hectares of the present county and borough, and the sixteen original parishes lying within Cardiff's present-day boundaries have become the thirty-two communities of the contemporary city. The present community of **Butetown** (*Tre-biwt*: 392 hectares; 3,251 inhabitants) is a somewhat truncated version of the old parish of St Mary, and that of the **Castle** (*y Castell*: 172 hectares; 674 inhabitants) is a shrunken version of the old parish of St John. Thus, by the late twentieth century, when a mere 3,925 people lived in those two communities, only 1.38 per cent of Cardiff's 283,371 inhabitants lived in what was, in the mid-nineteeth century, virtually the town of Cardiff in its entirety.

The best place to begin an exploration of the communities inhabited by 98.62 per cent of Cardiffians is to walk down Queen Street, and then on to Newport Road beneath the bridge built by the Taff Vale Railway Company. The walk involves leaving the confines of the old parish of St John and entering the old parish of Roath, the eastern part of the Cardiff extension of 1875. The parish was the area between the original borough and the lower reaches of the Rhymni River. It extended over 1,400 hectares and now consists in the main of the communities of Adamsdown, Splott, Roath, Plasnewydd and part of that of Cathays. **Adamsdown** (*Twynadda*: 107 hectares; 7,594 inhabitants) is the area between Newport Road and the South Wales Railway. It

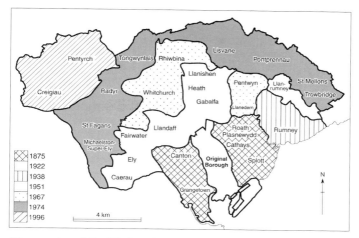

The extension of Cardiff's boundaries, 1875–1996.

preserves the name of the Bute-owned, 162-hectare, Adamsdown farm. The successive rents paid by its tenants provide a clear indication of the way the farm contracted as Cardiff's eastern suburbs expanded. The rent – £504 in 1826 – was reduced in 1827, 1847, 1860, 1870 and 1880. By then, all the farm's fields had been built upon and the farmhouse would shortly be demolished. Adamsdown represents Cardiff's first major expansion. By the early 1850s, a congested settlement had come into being east of Adamsdown Square, an extension of the little Ireland already in existence at Newtown. A map of 1869 shows that, further to the north, a rather more spacious street alignment had been laid out, and the streets were named after heavenly bodies (Star, Sun, etc.) or metals (Tin, Silver, etc.) or gemstones (Ruby, Topaz, etc.).

Adamsdown was also the site of those markers of Cardiff's growing importance – the prison, first established in 1832, the barracks built following the Chartist unrest of the late 1830s, and Cardiff's first municipal cemetery, opened in 1848. The prison was greatly enlarged in 1876 and its high walls dominate the western end of Adamsdown. The barracks were demolished in the 1870s and the site came to be occupied by the extensive

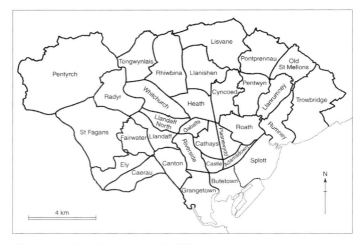

The communities of present-day Cardiff.

neo-Gothic buildings of the Royal Infirmary, buildings whose future is now in doubt. The hospital's bulk gives a swagger to the south side of Newport Road, where the vista is further enhanced by the fine towers of St James and Trinity churches.

The cemetery was eventually superseded by the one opened at Cathays in 1859. The old cemetery is now Adamsdown's sole open space, with fascinating gravestones lining its boundary walls. Among the most interesting commemorative inscriptions is that to Mary Jenkins (died 1891) who 'in 1872 . . . took a firm and uncompromising stand against the sale of All Saints Welsh Church to the Roman Catholics which was promoted by the bishop of Llandaff and other influential persons'. All Saints was established as a place of worship for Welsh-speaking Anglicans by the dowager marchioness of Bute, and opened in Tyndall Street in 1856. The dispute concerning the church was an episode in the conflict between the Welsh and the Irish, which found expression in riots in 1848 and 1886. Mrs Jenkins's campaign was successful, for All Saints continued to serve Welsh-speaking Anglicans until 1901, when the building was sold to the Great Western Railway Company. In that year, it was relocated in

84

Kames Place, ten years after Adamsdown was endowed with a second Welsh church – Eglwys Dewi Sant in Howard Gardens, destroyed in the Second World War. (By now, the church for Cardiff Anglicans worshipping in Welsh is that of Dewi Sant, north of Windsor Place.)

The building of Anglican churches was an almost frenzied activity in the largely Nonconformist Cardiff of the late nineteenth century. More than a score were built, the finest of which is St German's in Metal Street, Adamsdown. Completed in 1884, it was the building which introduced late Victorian Gothic to Glamorgan. It has long been Cardiff's chief centre of High Anglicanism and, together with churches at Butetown, Grangetown and elsewhere, it represents the heroic efforts of the inheritors of the Oxford Movement to bring 'the beauty of holiness' to deprived communities.

More dominant than the churches are the office buildings at the west end of Newport Road, the beginnings of an abandoned attempt to give Cardiff a skyline of tower blocks. The most assertive of them is Brunel House (1974), a sixteen-storey slab which, as John Newman puts it, 'makes absolutely no concession to its surroundings'. Further along is the rather more imaginative Hodge Building, the main offices, until the completion of the county hall in 1987, of the South Glamorgan County Council. A more modest, but highly attractive building, is that of the Magistrates' Court nestling in the corner of a group of streets whose names have associations with Gwendoline, daughter of Lord Howard of Glossop and wife of the third marquess of Bute.

Most of the area south of Newport Road – Adamsdown included – has long been known as Splottlands, but the present-day community of **Splott** (y Sblot: 526 hectares; 10,188 inhabitants) is that district which lies between the main railway line and the sea. The name is intriguing; as the area was originally ecclesiastical land, it may be a corruption of God's plot. (Its gentrification as Splô is surely an urban myth.) The Ordnance Survey map of 1890 shows that then the entire region south of the main railway had no settlements apart from the farms of Splott and Pengam and a cluster of congested streets bearing the names of the Scottish properties of the marquesses of Bute. What transformed the situation was the establishment in 1891 of

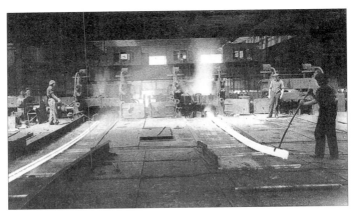

A photograph of about 1940 showing a steel section being rolled in the Lamberton bar mill at the East Moors Steelworks.

a major steelworks at East Moors. As technological advances were creating the need for richer iron ore than was locally available, the metallurgical industries of the northern rim of the coalfield – the industries which provided the original impetus for the expansion of the port of Cardiff – were obliged to import ore. Burdened with the cost of conveying the ore forty kilometres inland, the Dowlais Iron Company's directors decided to establish a steelworks adjoining Cardiff Docks. The East Moors works rapidly became the largest single employer in Cardiff. For more than three-quarters of a century, the city's night sky was dramatically illuminated by the opening of its furnaces.

The establishment of the steelworks gave rise to what Rhodri Morgan has called 'the hot-metal sub-culture of Splott, Tremorfa, Adamsdown and Llanrumney', a sub-culture wholly unfamiliar to those not venturing south of Newport Road. The closure of the steelworks in 1978 represented the culmination of the de-industrialization which Cardiff experienced in the second half of the twentieth century. That process has caused a city once heavily reliant upon work in transport and heavy industry to become overwhelmingly a city of white-collar jobs in service industries. The steelworks have been demolished and replaced by

a business park, an estate of workshops and the Welsh National Tennis Centre.

Splott had had earlier experiences of demolition. They include the removal of fifteen streets west of Morland Road, streets whose inhabitants included many of those who migrated to the more commodious houses of the council estate at Ely. They also include the dismantling of the buildings of Cardiff's Municipal Airport, opened on Pengam Moors in 1930 and closed in 1954. (Part of its site is now occupied by a secondary school aptly named after E. T. Willows, the airship pioneer and the first man to fly across the Severn Sea.) Further demolition occurred when the Rover plant, established at Tremorfa in a blaze of optimism in 1963, was closed in the 1980s. (Rover Way, Splott's horseshoe road, is a sad reminder of that optimism.) Now, however, an ambitious project is planned for Splott: it is the building of the East Bay Road which, if the necessary finance is forthcoming, will hug the Tremorfa foreshore – Splott's extensive but virtually unknown and inaccessible stretch of coastline. When completed, the road will link Cardiff Bay directly to the M4 motorway and will provide convenient access to the considerable areas of development land available in southern Splott.

Rover Way takes the traveller back to Newport Road through an array of depots, warehouses, garages and superstores. Across the road lies the community of **Roath** (*y Rhath*: 335 hectares; 11,106 inhabitants) which encompasses less than a fifth of the medieval parish of Roath. The Roath of the Middle Ages was a manor organized as Cardiff Castle's provisioning centre. In the early fourteenth century, it had eighteen bond tenants working under the supervision of a reeve to provide the castle household with grain, meat and dairy produce – the 308 cheeses produced in 1316, for example. The manor's close association with the castle meant that Roath was an integral part of the estate granted to William Herbert in 1547, and by the nineteenth century the manor consisted in the main of the farms of Crwys Bychan, Pen-y-waun, Pen-y-lan and Fair Oak, all of which are commemorated in the district's street names.

The area within the boundaries of the present-day community of Roath was not intensely urbanized until the early twentieth century. Indeed, the Pen-y-lan rental shows that, throughout the nineteenth century, the farm lost no land at all to housing. The

chief place of interest for those exploring the community is the church of St Margaret of Antioch at the junction of Albany and Waterloo Roads. In the Middle Ages, St Margaret's was the sole parish church for those parts of Cibwr lying outside the borough of Cardiff. A simple whitewashed building with a low bell turret, it was replaced in 1870 by a church designed by John Prichard whose work – much of it very distinguished – can be seen in many parts of Cardiff. It is well worth seeking to discover the times the church is open to tourists, for Prichard's quest for green, red and gold stone in the quarries of Glamorgan has resulted in a magnificent exercise in polychromy. Prichard also reconstructed the adjoining Bute mausoleum, built to house the tomb of Charlotte, heiress of the Windsors and the Herberts, and six other members of the Bute family. Charlotte's body was interred in the original mausoleum in October 1800, twelve days before her husband, the first marquess of Bute, married his second wife.

The northern part of the present-day community of Roath – Pen-y-lan – lies to the north of Eastern Avenue which, with Western Avenue, constitutes Cardiff's inner ring road. Pen-y-lan is the location of several schools and also of Cardiff's chief synagogue, built in 1955. Jews began settling in Cardiff in 1813, and the first synagogue was built in 1858 at East Terrace – now the bottom end of Churchill Way. Further synagogues would be built in Edwards Terrace, Windsor Place and Cathedral Road but, with Pen-y-lan becoming the main focus of settlement by Jews, the synagogue there has become their chief centre of worship. The achievements of Cardiff's tiny Jewish community are astonishing. Its members include Brian Josephson, the only Cardiff-born and, indeed Welsh-born, Nobel Laureate, and of the four renowned Cardiff-born English-language writers, one (R. S. Thomas) was Welsh, one (Roald Dahl) was Norwegian, and two (Dannie Abse and Bernice Rubens) are Jewish.

From Pen-y-lan, the explorer should return to Albany Road which is the boundary between the community of Roath and that of **Plasnewydd** (163 hectares; 14,042 inhabitants). Plasnewydd is the area immediately east of the railway to Caerffili and, with eighty-six residents per hectare, it is the most densely inhabited of Cardiff's communities. It contains some of the main features associated with Roath, among them the original centre of the manor which lay immediately across the road from St

Margaret's. The name Roath cames from *rath*, one of the rare Irish loanwords in Welsh, and means a defended enclosure. Rice Merrick's reference to a mound near the old manor house led William Rees to suggest that the mound was the site of the original *maerdy* or administrative centre of the early Welsh rulers of Cibwr. The building now occupying the site is Roath Court, a handsome early nineteenth-century villa embellished in 1956 by a stone porch designed by Robert Adam and brought from Bowood in Wiltshire. The house was the seat of the Crofts Williams family, whose members provided Cardiff with several of its mayors; it is now a funeral home.

The lords of Cardiff had mills at Roath powered by the flow of the Roath or Llechau Brook. For much of its course, the brook is in an underground conduit, but it can be seen in Roath Park where it forms the north-eastern boundary of the community of Plasnewydd. The greater part of the park, including the lake formed by the damming of the brook, lies within the community of Cyncoed, but its lower section is part of Plasnewydd. That section is overlooked by Ninian Road where the houses designed in the 1890s by the Bute estate architect, E. W. M. Corbett, match in style those designed by him for the concurrent Bute development in Cathedral Road.

At Penywaun Road, Bute land gave way to that of another Scottish-owned estate – that of Plasnewydd, the property of the Mackintosh family of Moy Hall, Inverness-shire. The estate originally belonged to the Richardses and also included land at Cyfarthfa and Aber-fan. (Moy Road, Aber-fan, the street overwhelmed by the appalling disaster of 1966, was named after the Mackintosh family's Scottish seat.) Arabella Richards, great-niece of E. P. Richards, chief agent of the Bute estate, became the heiress of the Plasnewydd estate when her father, also an E. P. Richards, drowned as a result of being thrown by his horse into a cartful of Cardiff's night soil. In 1880, she married Donald Mackintosh, the twenty-eighth chief of Clan Chattan. The couple immediately proceeded to lay out their land in streets, almost all of which bear Scottish names. By 1898, no open space remained apart from a garden around the old Richards family seat, the chunky battlemented mansion of about 1800 which was originally called Roath Castle but which has, since 1890, been known as the Mackintosh Institute.

South of Cyfarthfa Street, urbanization began earlier. The land was that of the Morgan family of Tredegar House, Newport, and was built upon from the mid-1850s onwards. The earliest development was that immediately to the north of the west end of Newport Road, where the family aimed at a dignified layout enhanced by streets with names like The Parade, The Walk, West Grove and East Grove. This was Tredegarville, and among its earliest buildings was Tredegarville Chapel (1861), a portent of the growing acceptance of the Gothic style by English-speaking (although not Welsh-speaking) Nonconformists. Contemporary with the chapel is the nearby church of St Peter, Cardiff's oldest surviving Roman Catholic church. The most intriguing building in Tredegarville is the house built in 1891 for James Howell, Cardiff's leading draper. So prudential was he that he feared that the house's large proportions would prevent him from receiving a good price for it should he ever wish to sell. He therefore insisted that it should be easily split into a semi-detached pair; it has paired entrance doorways, one of which is a dummy. It has survived as a single dwelling, for the Cardiff Corporation bought it as the official residence of the Lord Mayor.

From Tredegarville, explorers should make their way to Newport Road. It was here, on the road's north-western corner that, on 24 October 1883, 102 men and 42 women were accepted as the first students of Cardiff's University College. The ceremony took place in a plain Georgian-style building erected in the mid-1830s and financed by the profits of the Gwent and Glamorgan Eisteddfod of 1834, and the generosity of Daniel Jones of Beaupré. The building was the Glamorganshire and Monmouthshire Infirmary, which was sold to the college because a more ambitious infirmary was being built on the Adamsdown side of Newport Road. The old infirmary would be the only home of the college until the opening in 1909 of W. D. Caröe's masterpiece in Cathays Park. It was demolished in 1960, but long before then it had been encased within an array of college buildings, among them the astonishing Gothic entrance tower completed in 1915 to the designs of the dedicated Cardiff gothicist, E. M. Bruce Vaughan.

Further walks in Plasnewydd are recommended. For example, it is worth looking at Cardiff's two original high schools – that

for girls in The Parade (now Coleg Glanhafren) and that for boys in Newport Road. They represent Cardiff's sole efforts to exploit the possibilities of the Welsh Intermediate Education Act of 1889, and they could accommodate only a tiny proportion of the city's teenagers. The highly selective entry and the dedication of the teachers made them by far the most academically accomplished schools in Wales. The distinguished historian, R. T. Jenkins, taught at the boys' school from 1917 to 1930. 'It had', he wrote, ' a rather aristocratic atmosphere', although he added acerbically, 'at least according to Cardiff's idea of aristocracy.'

While in Newport Road, it is worth visiting Elm Street where the residents have painted their houses in a riot of colour, creating a townscape more akin to Portofino than to Plasnewydd. From Elm Street, sightseers should make their way to City Road, which was known in Welsh as Heol y Plwca (the lane of the plot of clay). The dangerous junction at the top of City Road was the site of the town gibbet, situated in a field called Plwca Halog (the unhallowed plot). A plaque on the NatWest Bank commemorates Philip Evans and John Lloyd, the Catholic martyrs, canonized in 1970, who suffered death there in 1679. Near the junction is the one-time Crwys Road Calvinistic Methodist Chapel. A remarkable hybrid built in 1899, it is one of several Cardiff chapels to have found a new function as a mosque.

South of the junction, the footbridge over the railway in Fitzroy Street takes the explorer from the community of Plasnewydd to that of **Cathays** (163 hectares; 11,109 inhabitants). Cathays is a V-shaped community hemmed in by the railway lines to Merthyr and Caerffili. The name comes from *haie* (hedge), and was that of a farm situated near the present Cathays Terrace. Its southern fields became the site of the park of Cathays House, a residence rebuilt by the first marquess of Bute and demolished by the second. In the context of Cardiff, the name Cathays evokes images of civic splendour, but the park and its glories are in the community of the Castle not in that of Cathays.

The eastern part of present-day Cathays was in the parish of Roath, while its western part lay within the old town parish of St John. Until the late 1870s, when building became intense, both parts were almost entirely rural. By 1900 Cathays had become the

first outlying part of Cardiff to be wholly urbanized. Before the extensive laying out of streets, the area had been seen as convenient for the location of land-intensive facilities. Cardiff's second municipal cemetery was established there in 1859. It is a place well worth visiting, for the tombstones provide a fascinating record of Cardiff's history. Among the most poignant monuments is that unveiled in the 1990s by President Robinson of Ireland 'in memory of the victims of the Great Famine in Ireland . . . and of all Irish people and their descendants who have died in Wales'. In 1871, Cathays became the location of Cardiff's barracks, following the closure of the smaller barracks at Long-cross. The headquarters of the Welch Regiment, it has a cenotaph by Lutyens, a smaller version of his memorial in Whitehall.

Cathays was developed as a network of modest streets containing artisan housing. By now, it is primarily a student quarter, providing bedsitters to the forty thousand and more students attending the city's various colleges. Within the Cathays community is the University College's earliest purpose-built building, the neo-Jacobean Aberdare Hall completed in 1895 to accommodate female students. The community also contains that pile of concrete, the library on Corbett Road. Cathays, however, can offer a far more attractive library – the charming pair of reading rooms facing Cathays Terrace and built in Arts and Crafts Gothic in 1906.

The north-western boundary of the community of Cathays is the dock feeder which draws its water from the River Taff at Blackweir. Blackweir offers access to Bute Park and the pleasant walk along the feeder to the suspension bridge across the river. The bridge leads to what was the southern part of the parish of Llandaff – the western wing of the area brought within Cardiff's boundaries through the borough enlargement of 1875. The district, together with the part of the old borough which lay to the west of the River Taff, is now divided into three communities. The path from Blackweir leads to that of **Riverside** (*Glan'rafon*: 259 hectares, 11,637 inhabitants), which extends from Llandaff Fields to Tudor Road, a fact overlooked by estate agents who find that the magic word Pontcanna inflates house prices in what is, in fact, north Riverside.

Riverside embraces the greater part of the green swathe which constitutes the heart of modern Cardiff. It is worth walking

The delectable Cathays Library, built in 1906. The photograph is that of the original drawing prepared by the building's architect, J. Allan Speirs.

across Pontcanna Fields, past the site of what was once the headquarters of the TWW television company and its successor HTV, a fact which explains Pontcanna's development as Cardiff's media suburb. The path then skirts the Glamorgan Cricket Ground and the Welsh Institute of Sport and goes on to Sophia Gardens, the open space named after the widow of the second marquess of Bute and thrown open to the citizens of Cardiff in 1858. In the 1890s, the gardens provided the ground for the Riverside Cricket Club. In 1899, the problem of keeping the players together in the winter led the football enthusiast, W. B. Wilson, to found the Riverside football team. In 1908, the team won recognition as the Cardiff City Football Club, and the club's achievements would become a major feature of Cardiff's twentieth-century history. In 1951, Sophia Gardens became the site of a large pavilion; its vast covered space provided accommodation for exhibitions, concerts and tournaments until 1982 when the roof collapsed in a snowstorm.

Cardiff was slow to expand west of the River Taff. In 1850, the area added to Cardiff twenty-five years later contained a few houses immediately beyond the bridge and a tiny settlement along what would be Romilly Road. It had no public buildings apart from the workhouse built in 1839 to serve the forty-four parishes of the Cardiff Poor Law Union. (The workhouse was

rebuilt in the 1880s; it became St David's Hospital in 1923 and now only its façade survives.) Development gathered pace in the 1850s with the creation of Sophia Gardens and the purchase in 1852 of forty-four hectares of land by the National Freehold Land Society. The society's land was virtually the only part of Cardiff where houses were built in accordance with the freehold system. Its core was Severn Grove, where the variety of house styles and plot sizes is in marked contrast with the uniformity characteristic of the leasehold development which occurred on the Bute and other large estates.

Riverside's great glory is that quintessential leasehold development, Cathedral Road. The road was laid out in the 1850s but the main era of house construction was the 1890s. Although the road presents a superb unity of design, hardly any building is an exact replica of its neighbour. The walls are Pennant Sandstone, the mullions and transoms Bath stone, and the façades are enlivened with gables, finials, lozenges and blind arcades, together with doorways topped by arches bewildering in their variety. In the 1970s, Cathedral Road was considered to offer an ideal site for commercial development. A number of the houses at its bottom end were demolished and replaced by office blocks, a process eventually abandoned following protests by Cardiff's energetic Victorian Society. Cathedral Road's overall Gothic aspect is in splendid contrast with the Byzantine-like domes of the former synagogue, which was closed in 1989 and has been skilfully converted into offices.

For most Cardiffians, the image conjured up by the name Riverside is not the leafy pavements of Cathedral Road, or the almost equally lush surroundings of Plasturton Gardens. The image is that of the far more congested streets south of Cowbridge Road. That area was rapidly urbanized in the late 1870s. In the process, the Canna Brook, which gave its name to Pontcanna and Treganna (Canton), disappeared into an underground conduit which lies beneath King's Road, Neville Street and Brook Street. South Riverside is an archetypical inner-city suburb, its eastern streets named after lords of Cardiff Castle, its western after legal luminaries and those in the centre commemorating the engineers of the Bute Docks. It has become one of the strongholds of Cardiff's Afro-Caribbean and south Asian communities. Indeed, at 21 per cent, the community of Riverside

The original drawing of the Cathedral Road Synagogue, prepared by the architect, Delissa Joseph. Completed in 1897, the building was converted into offices in 1990.

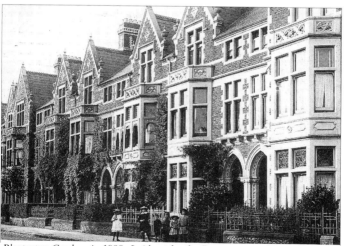

Plasturton Gardens in 1908. Laid out by the Bute estate architect, E. W. M. Corbett, and built in the 1890s, it is one of Pontcanna's most agreeable streets.

is second only to that of Butetown (40 per cent) in its proportion of non-white inhabitants – a fact hardly perceptible in that part of the community which is Pontcanna.

Cowbridge Road, the dividing line between north and south Riverside, leads to the community of **Canton** (*Treganna*: 308 hectares; 12,976 inhabitants). (The notion that Canton and Cathays are the names of Cardiff's Chinese quarters is wholly mistaken.) Canton prides itself on being Cardiff's premier suburb and has proved attractive to young professional people, Welsh-speakers in particular. The western boundary of the community of Canton runs along Llandaff and Leckwith Roads. Crossing it leads to Canton's finest architectural feature, the church of St John, demurely located in its crescent. Designed in 1854 by John Prichard, its construction coincided with the earliest stage of Canton's urbanization, but its crowning glory, its magnificent steeple, was erected in 1870 in accordance with the plans of W. P. James.

From St John's, it is worth walking up Llandaff Road to visit the vigorous and innovative Chapter Arts Centre, formerly Canton High School. The road leads on to Thompson's Park, once the private garden of Preswylfa, the home of the Thompson family, owners of the Spillers flour company, who presented the park to the citizens of Cardiff in 1924. (The family also financed the purchase of Llandaff Fields as a public park.) From Thompson's Park, Romilly Road leads to Victoria Park, carved out of Llandaff Common and opened to the public on the occasion of Queen Victoria's Diamond Jublilee in 1897. It was the home of Billy the Seal, a female grey seal who arrived at Cardiff Docks in a box of fish in 1912. She swam away from the park during the flood of 1927 and was returned to Canton by tram. Billy died in 1939 and her skeleton survives in the National Museum. She was, for decades, Cardiff's most famous denizen. The subject of one of Frank Hennessey's best-known songs, she is commemorated in Victoria Park by David Petersen's effigy.

On leaving Victoria Park, sightseers should walk down Cow-bridge Road to Norfolk Street to appreciate the astonishing neo-Tudor Lansdowne Road school, built in 1898 to accommodate 1,500 pupils. South of Lansdowne Road lies the area taken from the parish of Leckwith in 1875. It is a district of warehouses and car showrooms, the western equivalent of the development along

Newport Road. It also includes Ninian Park, the home of Cardiff City Football Club, soon to be refurbished, and of the Cardiff Athletic Stadium, 'a colourful and memorial object', to quote John Newman. At the bottom end of Leckwith Road lies one of Cardiff's hidden gems – the late medieval Leckwith Bridge, the area's oldest structure, now hidden under later road schemes.

From Leckwith Road, Sloper Road leads to **Grangetown** (*Trelluest*: 425 hectares; 11,684 inhabitants), a peninsula between the Taff and Ely rivers and the southernmost part of the territory added to Cardiff in 1875. In the mid-nineteenth century, Grangetown had no buildings at all,

Billy the Seal in about 1930. From 1912 until her death in 1939, Billy, a female grey seal, lived in a pool in Victoria Park.

apart from Grange Farm which still stands in Clive Street. The Grange was the centre of the land granted to the Cistercian monastery of Margam in about 1200. Following the dissolution of the monasteries, it came into the possession of the Lewis family of Fan near Caerffili, whose property passed by marriage to the Windsor family, earls of Plymouth, in 1736.

In 1859, the family began laying out its land, with the particular intention of encouraging industrial development. As so often in Cardiff, such developments did not flourish, and Grangetown became a district dominated by working-class housing. Two distinct communities – Upper and Lower Grangetown – had emerged by the mid-1880s. They were linked over the following decade, and the growing Grangetown became the stronghold of Cardiff's highly successful baseball team, founded in 1892. While the majority of the streets were situated on Windsor land, those nearest to the River Taff were laid out on the West Moors, the property of the Bute estate. The superiority of the Bute-designed streets with their open spaces and their houses with bay windows and front gardens is immediately

apparent. In the main, the houses were built for workers at the Bute and the Penarth Docks. Access to the Bute Docks was provided by a bridge across the Taff built by the Taff Vale Railway Company. The company's imposition of a toll aroused deep antagonism and led to the erection of a public swing bridge opened by the duke of Clarence in 1890. (The present Clarence Bridge was built in 1976). The Penarth Dock was reached via a ferry across the Ely, recalled in the name Ferry Road, and from 1881 transport to the ferry was provided by horse-drawn trams.

The trams were the property of Solomon Andrews, one of the most colourful figures in the history of Cardiff, who spent much of his wealth developing Cardiff Road, Pwllheli. Andrews was a major housebuilder in Grangetown. However, Cardiff's greatest builders were the Turner family who resided in what is now the Inn on the River in Clydach Street and whose workshops provided a major source of employment in Grangetown. In the 1890s, the family firm built a thousand houses, five hundred shops, forty-seven places of worship and twenty schools at Cardiff, and in the following decade the Turners were the main contractors for the buildings in Cathays Park. Their work in Grangetown includes the fine St Paul's Church in Paget Street and several schools, the massive pile in Sloper Road among them. By now, however, Grangetown's most famous – or perhaps most infamous – piece of architecture is the gasholder on Ferry Road. Erected in 1881, it is a remarkable construction in plated metal supported by cast-iron Doric columns. Its listed status precludes its demolition, much to the frustration of developers who wish to endow Grangetown with yet more retail outlets. Visitors to the gasholder should then walk to the Marl Playing Fields to enjoy the view of the mouth of the Taff. Immediately across the water lay the opening of the sea-lock pond of the Glamorganshire Canal, the root cause of the rise of Cardiff. On reaching the Marl, sightseers will have explored the entire swathe of territory brought within the town's boundaries in 1875, the first layer to surround the onion that was the old borough.

In 1922, a second layer was created, the expansion causing the area within the city's boundaries to rise to 4,800 hectares. The additional territory is essentially that represented by nine of the thirty-two communities of present-day Cardiff. It centred upon **Llandaff** (*Llandaf*: 255 hectares; 8,430 inhabitants), the ancient

ecclesiastical centre of south-east Wales. (The widely held belief that Cardiff is a city because there is an Anglican cathedral within its boundaries is wholly mistaken. City status was granted seventeen years before Cardiff included Llandaff and, had the town's elevation been dependent upon Anglican privilege, it would have been rejected by Cardiff's largely Nonconformist councillors.)

In 1840, the cathedral village of Llandaff was the lower Taff Valley's largest settlement outside the ancient borough. That is not to say very much, for it consisted merely of a few streets of cottages and two or three houses for ecclesiastical dignitaries – a bishop's residence conspicuously absent among them, for no bishop had lived at Llandaff since the Middle Ages. On the Green were crumbling thirteenth-century buildings – the bishop's castle and a massive bell tower. The cathedral was little more than a ruin, for its fabric, erected between 1120 and 1495, had suffered three centuries of neglect.

In the 1840s the ecclesiastical authorities awoke to their responsibilities. Restoration of the cathedral began, and when Alfred Ollivant in 1850 moved into Llandaff Court – the former seat of the Mathew family – Llandaff acquired a resident bishop. (The Court became the Cathedral School in 1958 following the building of a more modest house for the bishop.) The Green was endowed with additional ecclesiastical residences and Llandaff's main street was graced with Prichard's fine Probate Registry. At the same time, Llandaff was becoming a popular location for the mansions of Cardiff's merchant princes, with Rookwood (now a hospital) built as the seat of the Hill-Snook family of dry dock owners, and Ely Rise (now the Insole Court Community Centre) as that of the Insole family of colliery owners.

The district was also provided with an endowed school. In 1852, the Drapers' Company was permitted to use some of the money bequeathed to it by Thomas Howell in the sixteenth century to establish a girls' school at Llandaff. Howell's School, a vast neo-Gothic pile built in 1859, survives more or less intact, which is more than can be said of the 'orphan inmates' who, according to the founder, were to be the primary beneficiaries of the charity.

Despite the developments of the later nineteenth century, it was not until the twentieth century that Llandaff was firmly linked

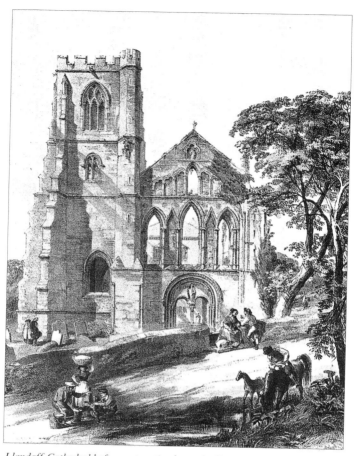

Llandaff Cathedral before restoration began in 1841.

with Cardiff by a continuous built-up area, the growing urban-
ization providing the justification for the absorption of Llandaff
by Cardiff in 1922. Two years later, Llandaff received its finest
monument – Goscombe John's memorial to the dead of the First
World War.

100

Llandaff Cathedral

The cathedral is the mother church of the diocese of Llandaff, which now consists of the old county of Glamorgan, east of the River Tawe. (Until 1922, it also included the old county of Monmouth.) South-east Wales probably had some form of diocesan organization from the fifth century onwards, and *Liber Landavensis*, compiled in about 1130, purports to prove that Llandaff had been a diocese, extensive in area and substantial in property, for at least six hundred years. However, there is no fully authentic record linking the bishop of Glamorgan with Llandaff until 1119. To stress its antiquity, the bones of St Dyfrig were transferred there from Bardsey Island. (Llandaff already had one of the three alleged bodies of St Teilo.) In 1120, Bishop Urban began replacing the 8.5-metre-long church but, apart from the fine sanctuary arch, his work was demolished by later bishops. The chapter house and the piers of the nave date from the early thirteenth century, and the Lady Chapel from the late thirteenth and early fourteenth centuries. With the completion in the 1490s of the west tower, believed to have been commissioned by Jasper Tudor, the cathedral was 80 metres in length.

As John Newman put it, 'no ancient cathedral in Wales or England has suffered a more chequered post-medieval history'. The alienation of the rich manor of Llandaff by Bishop Kitchen in 1553 drastically impoverished the see. Thereafter, the bishop of Llandaff was referred to as the bishop of Aff, for all the land had gone. Poverty led to the neglect of the building's fabric. By 1692, the insecure roof had led to the abandonment of choral services; the battlements of the north-west tower fell down in 1703, the south-west tower collapsed in 1722 and the walls of the nave were reduced to mere footings. In 1734, John Wood initiated the building within the ruins of a conventicle based upon the dimensions of Solomon's Temple. The project was left incomplete in 1752, and Llandaff Cathedral came to be considered a 'medley of absurdities'.

Restoration began in 1841 under the guidance of John Prichard, son of one of the cathedral's vicars-choral. Wood's

conventicle was demolished, the surviving medieval stonework was rebuilt where fragmentary, the nave was reroofed and a new south-west tower was erected on a scale sufficient to give the building an air of consequence it had previously lacked.

The work, completed in 1869, remained inviolate for seventy-two years. Then, in 1941, a century after restoration had begun, a wartime landmine shattered the cathedral. The roof of the nave fell in, and all the windows were destroyed. The rebuilding was no slavish reconstruction. Carried out by the innovative architect, George Pace, and completed in 1964, it involved the erection of a vast concrete arch bearing Jacob Epstein's *Majestas*, and the addition of the Welch Regiment's modernistic memorial chapel.

Although the disestablishment of the Anglican Church in Wales in 1920 means that Llandaff Cathedral has long ceased to be the chief official place of worship in the Cardiff region, it still retains that role in public sentiment. Among the memorable services held there in recent years was that in 1999 on the occasion of the inauguration of the National Assembly for Wales.

The northern part of the community lay undeveloped until the 1960s. In 1967, the headquarters of the BBC in Wales was located there; it is a reinforced concrete structure designed by the firm of Percy Thomas. Danescourt, the housing development to its north, is of recent construction and is the main explanation for the increase of 31 per cent in the population of Llandaff between 1981 and 1991 – a contrast with the communities of inner Cardiff, where the number of inhabitants stagnated or declined during that decade.

From Llandaff, explorers should make their way to **Fairwater** (*Tyllgoed*: 306 hectares; 12,471 inhabitants). Until the mid-twentieth century, Fairwater was mainly open country with a scattering of rural villas, among them Tŷ Bronna, built for the Watson family on St Fagan's Road in 1903. It was designed by Charles Voysey, the disciple of Ruskin and Morris; with its hipped roof and angle buttresses, it is perhaps twentieth-century Cardiff's most interesting house. (It is now the headquarters of the South Glamorgan Ambulance Service.) Fairwater, along with

its associated neighbourhood of Pentrebane, consists almost entirely of later twentieth-century housing developments. At its centre is St David's, probably the world's only Lutheran church dedicated to a Welsh saint.

South of Fairwater lies **Ely** (*Trelái*: 222 hectares; 15,389 inhabitants), the district lying south-west of the main railway line and north of Cowbridge Road. Apart from a dribble of buildings along that road and a small settlement at Ely Bridge, it consisted in 1922 almost entirely of open country. The argument for including it within Cardiff's boundaries was that it offered a large tract of land admirably suited to fulfil the corporation's ambition to provide decent working-class housing on a very extensive scale. Those ambitions were carried out in the late 1920s under the influence of the Garden City movement. The spine of the housing development is Grand Avenue which is flanked by commodious semi-detached houses. The families who moved to the new houses from the deprived streets of Adamsdown, Splott and Butetown were lyrical about the delights of their new surroundings. However, in more recent years, sparsity of amenities and high unemployment have created major problems. Although Ely has one of Cardiff's lowest proportions of non-white inhabitants, it suffered a bitter race riot in 1991.

Adjoining Ely to the south is the community of **Caerau** (294 hectares; 9,839 inhabitants). It was urbanized in the 1950s and 1960s as a later version of Ely. Caerau's equivalent of Grand Avenue is Heol Trelai, a dual carriageway divided by a wide stretch of grass. Caerau was a medieval parish and has parish registers dating back to 1741. The parish church – one of the fifteen parish churches built in the Middle Ages within Cardiff's present boundaries – can be reached by a rough track at the end of Church Road. It was deconsecrated in 1973 and is now a melancholy ruin. It is located within an Iron Age hillfort which also contains an early medieval ringwork castle. Caerau has another early monument. It is the Roman villa situated in Trelai Park, a vast open space which from 1886 until 1939 was the location of Cardiff's racecourse. All that can now be seen of the villa is a series of mounds surrounding a burned-out car.

Those exploring the Cardiff onion's second layer should leave Caerau along Cowbridge Road and follow Western Avenue to the junction with Aberporth Road, which gives access to the

103

community of **Llandaff North** (*Ystum Taf*: 199 hectares; 7,839 inhabitants), the district between the Taff and the railway line to Merthyr. Its houses are a trifle more upmarket than those of communities to its south and occupy the fields of the farms of Maendy and Llandaff Bridge, which were almost entirely unbuilt upon at the opening of the twentieth century. Llandaff Bridge offers a view of a fine stretch of the River Taff, where the headquarters of the Cardiff Rowing Club is located. The bridge leads to Ysgol Glantaf, Cardiff's Welsh-medium secondary school, and on to the Cow and Snuffers tavern, allegedly Benjamin Disraeli's lodgings when he was courting the widowed Mrs Wyndham Lewis of Greenmeadow, Tongwynlais.

Across Western Avenue lies the community of **Gabalfa** (127 hectares; 5,950 inhabitants), a cluster of mainly early twentieth-century streets named after the dominions of the British Empire. The word *gabalfa* comes from the Welsh *ceubalfa*, the place of the ferry, and refers to the boats which once crossed the Taff near the Western Avenue bridge. Gabalfa is now mainly known as a road interchange – the crossing of Eastern Avenue by North Road, Cardiff's modest version of Birmingham's Spaghetti Junction.

From Gabalfa, Allensbank Road leads to the community of **Heath** (*Y Waun Ddyfal* or *Mynydd Bychan*: 315 hectares; 11,939 inhabitants), which was for centuries part of the borough's common land, where townspeople grazed their cattle, dug for peat and harvested reeds and straw for their thatched roofs. By the late eighteenth century, it had attracted many squatters who had built *tai unnos* (rough cabins erected in one night). In 1799, a force of cavalry ejected the squatters despite their resistance – that of the women in particular. As John Bird, the marquess of Bute's secretary, put it: 'they acted the part of Amazonians having armed themselves with Pitchforks, etc., etc.' In 1802, an Act of Parliament enclosed the common and the part allotted to Cardiff Corporation still survives as Heath Park. The area was not urbanized until the twentieth century and is now dominated by the University Hospital, the teaching hospital of the University of Wales School of Medicine. Built between 1963 and 1992, the huge complex occupies what was the sylvan retreat of Allensbank Wood.

North of Heath lies the community of **Llanishen** (*Llanisien*: 496 hectares; 13,548 inhabitants), the lower part of which was

annexed by Cardiff in 1922. In the later Middle Ages, Llanishen emerged as one of the parishes of Cibwr and its fifteenth-century parish church, vastly enlarged in 1908, lies at the centre of what was, by the late nineteenth century, a substantial village. There was much building in the inter-war years and again from the 1960s onwards, when numerous culs-de-sac were laid out on the lower slopes of Thornhill. Llanishen's most attractive feature is the reservoir constructed in 1878, Cardiff's main source of water until the creation of three lakes in the Brecon Beacons between 1892 and 1908. The haunt of many water birds, Llanishen Reservoir is the only open space in Cardiff charging an admission fee.

Fidlas Road takes the explorer to the community of **Cyncoed** (327 hectares; 10,255 inhabitants). It is an area of opulent houses built in the 1920s and 1930s; none of them, however, was deemed worthy of mention in John Newman's study. It includes the chief campus of the University of Wales Institute, Cardiff, and the verdant expanse of Cardiff Golf Course, one of the city's five courses. The twelve-hectare Roath Lake, excavated in 1889, is also within Cyncoed's boundaries. The lighthouse on the lake's dam was erected in 1912 to commemorate Scott's doomed Antarctic expedition.

Cyncoed brings to an end the tour of Cardiff's 1922 expansion. The next expansion was that of 1938. It would be reasonable to expect that this would have involved the parish of Whitchurch, which was by then an integral part of the city's built-up area. However, its prosperous inhabitants had no wish to become Cardiff citizens, preferring to continue to enjoy the lower rates and the presumed rusticity of the Cardiff Rural District. Furthermore, the main motive of the city's councillors in seeking expansion was to acquire sites for working-class housing. They thus sought open land on the city's eastern fringes to match the already built-up land at Ely on its western fringes. They secured the annexation of the parish of Rumney and part of that of St Mellons, both in Monmouthshire. There were those who considered the annexation to be somewhat incongruous. Cardiff's great ambition was to be recognized as the capital of Wales. Why therefore did it covet part of a county which, in 1938, was widely considered to be part of England? (As late as 1961, the Ordnance Survey one-inch map showed Cardiff

bisected by the Wales–England border.) Yet, as has been seen, Cardiffians had long considered that it was in their interest to secure Monmouthshire's recognition as part of Wales, an issue finally settled by the local government reorganization of 1974.

The core of the 1938 annexation is the present-day community of **Rumney** (*Tredelerch*: 346 hectares; 8,752 inhabitants). It was extensively urbanized in the 1950s, although its southern part, the Lamby Moor adjoining the estuary of the River Rhymni, is still largely open country. The remains of a castle were once visible but they were built over in the 1980s. The church of St Augustine has interesting medieval features and the pottery near Rhymni Bridge is a long-standing family concern.

Cardiff's fourth expansion, that of 1951, involved a further part of Monmouthshire. That annexation is essentially represented today by the community of **Llanrumney** (*Llanrhymni*: 305 hectares; 12,121 inhabitants). It is a vast housing estate interspersed with extensive playing fields. Within its boundaries is the splendidly located church of St Mellon which, apart from St John's in the city centre, is the finest medieval church in present-day Cardiff.

Between Llanrumney and Cyncoed lay the rural parish of Llanedern, and in 1967 much of the parish came within the boundaries of Cardiff. The core of the annexation was what is now the community of **Pentwyn** (*Pen-twyn*, not *Pent-wyn*: 368 hectares; 16,579 inhabitants) which, in 1991, was the most populous of the city's communities. A typical late twentieth-century suburb with a variety of schools, it has an attractive lake in Wern-goch Park.

The expansion of 1967 also included much of the hitherto unscathed parish of Whitchurch where, between 1951 and 1961, the population had risen from 19,827 to 27,325. The 1,300-hectare parish extended to Caerffili Mountain and its southern part is now the community of **Whitchurch** (*Yr Eglwys Newydd*: 428 hectares; 12,663 inhabitants). Although most of its streets were laid out in the late nineteenth and early twentieth centuries, Whitchurch has been a significant settlement since the mid-eighteenth century, the consequence of the establishment of the Melingriffith Tinplate Works in 1749. By the 1880s, the works had fifteen hundred employees and they continued in operation until the 1940s; they were thus by far the most long-lasting of the

106

industrial concerns of the Cardiff region. They have now been demolished, but the weir and feeder which provided them with water power can still be seen. They are in the Forest Farm Country Park, a delightfully sylvan place which also contains the city's sole surviving stretch of the Glamorganshire Canal. At the northern end of the park stands the Amersham Radiochemical Centre, Cardiff's most successful building in the modernistic idiom. Across the canal from the centre lay the house built for shipowner John Cory, which has given the adjoining settlement the name Coryton.

South of the park stands the herringbone-plan mental hospital built in 1903, its massive bulk dominating the scene. From there it is worth walking down to the river to see John Rennie's water pump, constructed in 1807 for the Melingriffith Works. It is situated on Ty Mawr Road, named after Tŷ Mawr, a much-altered sixteenth-century house; the date of its erection (1583) is carved on the lintel of the hall fireplace. From there, Church Road takes the explorer to the centre of Whitchurch where the footings of the original parish church may be seen in Old Church Road. (The old church was once a new one, as the parish's Welsh name indicates.) Its replacement was built in 1882 and stands in a large and fascinating graveyard.

The northern part of the parish of Whitchurch is now the community of **Rhiwbina** (*Rhiwbeina*: 642 hectares; 10,796 inhabitants). Rhiwbina's great attraction is the garden village built in two phases – in 1912–13 and in 1922–3. The houses were designed by A. H. Mottram and T. Alwyn Lloyd and erected by the Cardiff Workers' Co-operative Garden Village Society which was wound up in 1976. The society's prospectus, written in the reformed orthography favoured by Bernard Shaw, stated that the houses were intended for 'scild artisans, clarcs, shop asistants and uthers ov moderait incums'. Yet, as ambitious schemes for working-class betterment are always hijacked by the middle class, shop assistants are now wholly unable to afford to buy a house in Rhiwbina. The street names were dreamt up by one of the residents, Professor W. J. Gruffydd. They are all in Welsh – fittingly perhaps for, at 11 per cent, Rhiwbina in 1991 had Cardiff's highest proportion of Welsh-speakers.

The garden village is the group of streets west of Lon y Deri and is now a conservation area. Most of the rest of Rhiwbina's

A drawing, prepared in 1913, of the layout of the Rhiwbina Garden Village.

streets date from the 1960s when the farm of Llanishen Fach was intensively urbanized. Northern Rhiwbina beyond the motorway is the open space of Coed y Wenallt, which reaches up to the summit of Cefn Cibwr. Even its southern part has extensive open spaces, including the wide expanse of Whitchurch Golf Course, the gardens of the Thornhill Crematorium and the land surrounding Y Twmpath, one of Glamorgan's largest mottes, constructed in the twelfth century as part of Cardiff's defences against the Welsh.

Cardiff's next expansion, that of 1974, occurred in the context of a major local government reorganization. It involved a band of territory on Cardiff's north-eastern and north-western fringes. Perambulations of the additional territory should start in the community of **Trowbridge** (921 hectares; 12,702 inhabitants) which, before the boundary change, constituted most of what remained of the parishes of Rumney and St Mellons. It represents Cardiff's intrusion into the Gwynllŵg (Wentloog) Levels, where the landscape is Dutch rather than Welsh. Within the community is a stretch of coastline where the city of Cardiff seems remote indeed. Most of the community is still unbuilt upon, and the urbanized areas are Trowbridge itself and the vast housing

108

development of St Mellons, centred upon a dense series of streets encircled by Willowbrook Drive. With a population increase of 101.4 per cent between 1981 and 1991, Trowbridge was by far the fastest-growing part of Cardiff during that decade. In 1991, it was the city's youngest community with 31 per cent of its population under the age of sixteen. While secretary of state for Wales, John Redwood castigated its inhabitants, claiming that they consisted in the main of unmarried mothers living on state handouts. The St Mellons housing development represents a major eastern thrust of the city, and raises the possibility that the suburbs of Cardiff will eventually also be the suburbs of Newport.

Such is the overlaying of boundaries in this part of Cardiff that the district to the north of Trowbridge was known until 1996 as **St Mellons** (*Llaneirwg*: 856 hectares; 2,742 inhabitants). In that year, it was divided into **Old St Mellons** (*Hen Laneirwg*) and Pontprennau, communities for which separate statistics are not yet available. The choice of the name Old St Mellons represented an attempt by the inhabitants of that middle-class enclave, with their golf course and country club, to distance themselves from the new St Mellons in Trowbridge. The centre of the community, with its charming inns, still has a village air, and the large houses along the Began Road are in a different world from that of Trowbridge. Within the community's boundaries is Llanedern Church, the only parish church in Cardiff containing evidence of the Romanesque style.

Extensive housebuilding in Old St Mellons may not occur, for much of the community lies within the Rhymni flood plain. The adjoining community, that of **Pontprennau**, is on higher ground and is now the fastest-growing part of Cardiff. It includes Cardiff Gate Retail Park with its vast B & Q warehouse, the city's largest store. So far, Pontprennau north of the M4 is wholly rural and offers pleasant walks in Cefnmabli Wood.

To the west lies the community of **Lisvane** (*Llys-faen*: 770 hectares; 3,199 inhabitants), Cardiff's seriously opulent suburb, where houses change hands at up to a million pounds apiece. Its centre, around the fourteenth-century church of St Denys, is still charmingly rustic, and within Lisvane's boundaries is the delightful Parc Cefn Onn, ablaze with azaleas in the spring. It is worth wandering its roads (it would be almost blasphemous to call them streets) to gaze at the mansions and their impeccable

gardens. The most interesting of the residences is number 66, Mill Road. It was designed for his own occupation by Edwin Seward, the architect of Cardiff's most ponderous buildings – the Central Library, the Royal Infirmary and the Coal Exchange.

Reaching the northern-western wing of the 1974 expansion involves traversing the communities of Llanishen and Rhiwbina to reach that of **Tongwynlais** (428 hectares; 1,739 inhabitants). Most of the community consists of Greenmeadow Wood, Fforest Fawr and the fields of the farm of Rhiwbina, which gave its name to the adjoining community. Greenmeadow, the home of Wyndham Lewis – a director of the Dowlais Iron Company, MP for Glamorgan from 1820 to 1826 and husband of Mary Anne, later the wife of Benjamin Disraeli – has been demolished. (The family is commemorated by the Lewis Arms, the inn in the centre of the village.) The great attraction of Tongwynlais is Castell Coch, Wales's most delightful landmark. (An admirable guidebook is available at the castle.)

From Tongwynlais, a footpath across the Taff provides access to the community of **Radyr** (*Radur*: 467 hectares; 4,208 inhabitants). The footpath passes Gelynis Farm, a fine sixteenth-century building, and leads to a motte erected in the late eleventh century as an adjunct to the motte across the Taff at Castell Coch. The motte adjoins the salubrious suburb of Morganstown, where the road goes beneath the M4 to Radyr itself. There, it is worth visiting Christ Church, completed in 1910 – Cardiff's last exercise in neo-Gothic church-building. In southern Radyr are the vast sidings where once the coal conveyed by the Taff Vale Railway awaited shipment at the docks.

At the western extremity of Radyr, Crofft-y-genau Road leads to the community of **St Fagans** (*Sain Ffagan*: 991 hectares; 713 inhabitants). With 0.7 residents per hectare, St Fagans is Cardiff's most thinly populated community. It is likely to remain so, for it is a central part of the city's green belt. Furthermore, much of it lies within the park of St Fagans Castle, the location since 1948 of the Museum of Welsh Life, Cardiff's most popular tourist attraction. (Published material on every aspect of the castle and the museum is available there.) Under the Windsor-Clive family, St Fagans was developed as a model estate village. Among the buildings commissioned by the family were the home farm of Pentrebane, the admirable rectory, the neo-Tudor

110

National School, the neo-Jacobean Plymouth Arms and the delightful thatched cottages below the castle. Within the community are two medieval churches – that of St Mary's at the centre of the village, with its fine fourteenth-century nave and chancel, and the church of Michaelston-super-Ely, the tower of which has a saddleback roof of a type much favoured in the Cardiff region.

The latest of the city's expansions is that of 1996, which coincided with the re-establishment of Cardiff as a county borough. It added to the city the parishes of Llanilltern and Pentyrch and now constitutes the community of **Pentyrch** (*Pentyrch*: 2,029 hectares; 6,189 inhabitants). Pentyrch, with its upland location, was considered to be a village aloof from the world, as the Welsh proverb, *Rhwng gwŷr Pen-tyrch a'i gilydd* (between the men of Pentyrch and each other), suggests. It was long a stronghold of the Welsh language; in the early twentieth century, well over half its inhabitants were Welsh-speaking, and Welsh was the main language of the inhabitants of the village of Gwaelod-y-garth until very recently. The considerable housing development there, and particularly at Creigiau and at Pentyrch village itself, has led to a decline in the proportion of Welsh-speakers although, as they constitute 15.1 per cent of the inhabitants, Pentyrch heads the list of Cardiff's communities in terms of the percentage capable of speaking the language.

Within the boundaries of Pentyrch are two medieval houses – Pencoed House at Capel Llanilltern and Castell y Mynach near Creigiau – and also the Lutyens-style mansion of Craig-y-parc completed in 1918. The community's northern edge is within the south Wales coalfield; thus Cardiff has at last reached the mineral deposits so central to its history. Pentyrch is overlooked by Mynydd y Garth, the highest point within Cardiff and the location of the city's oldest monuments – a group of Early Bronze Age burial mounds. The tour of outer Cardiff should conclude in the coalfield on the summit of Mynydd y Garth, from which the vista of the city is breathtaking.

5 City and Capital

In October 1905, Robert Hughes, the mayor of the town of Cardiff, received a message from the Home Secretary announcing that it was the king's pleasure that Cardiff be constituted a city and the chief magistrate be styled Lord Mayor. The announcement was a comment on the concept of the 'metropolis of Wales'. There were in Britain in 1905 at least a dozen towns larger than Cardiff which had ambitions to be raised to city status. As A. J. Balfour, the prime minister, put it: 'On its merits as a British town [Cardiff] has no claim, and if we are to have a Lord Mayor of Cardiff except on a Welsh ground we should lay ourselves open to claims from every town of large population.' His private secretary agreed, noting that the arguments advanced 'turned not so much upon the size of Cardiff, but upon its exceptional position and importance as a town in Wales'. The decision had much to do with the politics of the Conservative Party, which enjoyed more support in Cardiff than almost anywhere else in Wales, and owed something to the advocacy of Lord Edmund Talbot, a government whip and cousin and trustee to the marquess of Bute.

The corporation sought not only elevation to city status, but also an acknowledgement that Cardiff was the capital of Wales. That issue was regularly raised at the turn of the century in the hope that the status would ensure that all the national institutions which Welsh patriots were seeking to establish would be located at Cardiff. If it had had that status, the corporation believed that the Privy Council, when arbitrating on sites in 1905, would have been obliged to give Cardiff both the National Museum and the National Library of Wales. Cardiff secured the museum but, as the *Western Mail* put it, the library was 'banished to the cold shades of isolated Aberystwyth'. In the event, the city had to wait for fifty years before it was recognized as capital, and in achieving that status the politics of the Conservative Party were again of central significance.

The town of Cardiff had already begun to build monuments to its greatness at Cathays Park, a task continued with enthusiasm

112

by the new city. The City Hall was completed in 1906 and was opened by the nineteen-year-old marquess of Bute. (His father, the third marquess, had died at the height of the South African conflict in 1900, the *Daily Chronicle* remarking that 'the death duties will help to pay for the war'.) The City Hall is Cardiff's most superb building and, judging by the furore which followed its rejection as the home of the National Assembly, it is held in high regard by the people of Wales as a whole. It was the work of the architectural planner, H. V. Lanchester, and the draughts-man and elevation designer, E. A. Rickards, and their co-operation led to the construction of a Baroque masterpiece which attracted to Cardiff trainfuls of admirers who were dumb-struck by its splendour. Symbolic of Cardiff's ambitions is the snarling Welsh dragon on the dome and the statues of Welsh heroes in the marble hall adjoining the council chamber.

Lanchester and Rickards also designed the Law Courts, which are carefully aligned with the City Hall. Broadly contemporary with the two buildings is the first completed section of the University College – that facing Cathays Park. Designed by W. D. Caröe, the building contains what was once the most beautiful room in Wales – the College Library; sadly, its lower storey was floored over in 1977, thus ruining the library's superb proportions. Opposite the college lies the University of Wales Registry, its location at Cathays Park offering further evidence of Cardiff's ambitions. A tiny building, it cheerfully squeezes in between its massive neighbours – the Law Courts and the monumental structure completed in 1912 to house the chamber and offices of the Glamorgan County Council. To the north lies the building begun in 1913 for Cardiff's Technical Institute, the first work in Cardiff of the architectural firm of Percy Thomas, a firm whose imprint upon the city is now massive. Adjoining the City Hall is the National Museum of Wales, the foundation stone of which was laid in 1914.

This flurry of building is proof of the ebullience of the city in the early years of the twentieth century. Those were indeed Cardiff's halcyon years, when the new city's progress and growth seemed to be inexorable. Among its favourite sights were the noble shire horses dragging vast blocks of Portland stone from the docks to Cathays Park. There, five hundred employees of the firm of Ephraim Turner of Grangetown carved the stone

113

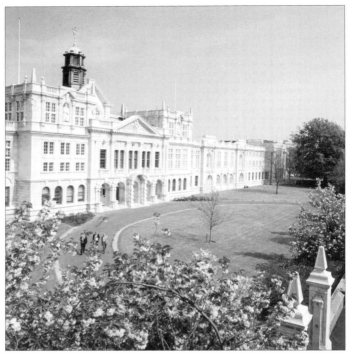

The western façade of the main building of Cardiff's University College. Designed by W. D. Caröe, it was built between 1905 and 1930. Initially, the Cardiff Corporation insisted that no building in Cathays Park should have a cornice line overtopping that of the City Hall. This accounts for the fact that the façade seems to be too low for its length.

of the City Hall and the Law Courts, the construction of which brought to the firm the astonishingly modest sum of £226,000. Those were the years in which, at last, Cardiff was provided with an efficient system of public transport. The corporation took over the various bus and tram companies in 1902, and by 1904 its services were carrying eighteen million passengers a year. The city had six theatres – the Philharmonic in St Mary Street (1876), the adjoining Theatre Royal, later the Prince of Wales (1878), the Park Hall in Park Place (1885), the Empire in Queen Street

114

(rebuilt in 1900), the Grand in Westgate Street (renamed the Hippodrome Palace in 1905) and the New in Greyfriars Road (rebuilt in 1906) – and, in addition, there were three cinemas in Queen Street by 1914. The early twentieth century also saw the extensive construction of public houses, the most attractive of which is the Golden Cross, with its superb murals of the castle and the old town hall. Beer production at Cardiff was dominated by the Brains and Hancocks Breweries. Samuel Arthur Brain – who gave his name to Brains SA – acquired his property at St Mary Street in 1882, and the brewery is still a Cardiff company. William Hancock began brewing at Crawshay Street, south of the Central Station, in 1884; the brewery is now owned by the Bass Worthington Company.

In leisure terms, the great excitements of the pre-war years were in the field of sport. The Cardiff Rugby Club, which had been established in 1876, secured a place to play on the land once occupied by the bed of the Taff. The playing field was that used in the summer by the Cardiff Cricket Club, founded in 1848. The ground came to be known as Cardiff Arms Park, taking its title from the Cardiff Arms Hotel, built in the late eighteenth century and demolished in 1878. (The hotel was named in honour of Lord Mountstuart – later the first marquess of Bute – who acquired the arms of the barony of Cardiff on his elevation to the British peerage as Baron Cardiff in 1776.) By 1904, the rugby club, in association with the Welsh Rugby Union, had raised a 40,000-capacity stadium in the park, the location of Wales's much-vaunted victory over New Zealand in 1905. Association Football also made advances. In 1910, the Cardiff City Club replaced its chocolate and amber strip with one in blue – the origin of the nickname 'Bluebirds'. In that year also, the club became a limited company with professional players, and acquired permanent premises on Sloper Road. Among its benefactors was the fourth marquess of Bute's brother, Lord Ninian Crichton Stuart, and, in recognition of his assistance, the team's new home was named Ninian Park.

Lord Ninian's role was evidence of the continuing involvement of the Bute family in the affairs of Cardiff. Yet, that involvement was vastly different from the almost total control enjoyed by the second marquess. By the later nineteeenth century, it was as a major ratepayer rather than as lord of Cardiff Castle that the third

marquess claimed a voice in government of the town. He was elected mayor in 1890 but acknowledged that he held the office 'as a kind of figure-head', for it was only when aristocratic influence was a spent force that the prestige of the peerage could be exploited to further civic dignity. The estate had lost its power to nominate Cardiff's MP in 1852, and the seat was not won again by the Conservatives until 1895, when the party's success had no significant Bute dimension. Lord Ninian was elected MP for Cardiff in December 1910, a victory attributable to rising Tory fortunes rather than to a revival of Bute influence. However, his links with the castle were stressed by the *Western Mail* and ignored by the Liberal *South Wales Daily News*, an indication that both his friends and his opponents considered that those links gave an added lustre to his candidature. Despite the fact that early twentieth-century Cardiff was essentially a working-class city, its substantial middle class meant that its political complexion was very different from that of the coalfield. The pre-war corporation included no Labour councillors. However, elements of the city's middle class could be politically militant. By 1911, membership of Cardiff's Women's Suffrage Society was the highest in Britain, outside London.

Cardiff's halcyon years came to an abrupt end with the out-break of war in 1914. Such was the rush to enlist that emergency recruiting offices had to be opened. Cardiff Arms Park became a training ground and many of the city's buildings – the Mansion House among them – were adapted to house wounded soldiers. Between 1914 and 1918, some thirty thousand Cardiffians enlisted, and over four thousand fell in battle. Among them was Lord Ninian, who was killed at Loos in October 1915 while commanding the sixth battalion of the Welch Regiment. As the war proceeded, it came to have an impact upon every aspect of Cardiff's life. Food became increasingly scarce; most of the city's parks became vegetable gardens and Billy the Seal was put on half rations. The demand for munitions caused production at the East Moors steelworks to break all records. The Campbell steamers which plied the Severn Sea and the ships of Cardiff's fishing fleet were commissioned as mine-sweepers. Cardiff's shipping tycoons made vast fortunes, despite the massive losses caused by U-boat attacks. At the war's end, the cruiser HMS *Cardiff* led the British Grand Fleet to its rendezvous with the

German Grand Fleet. The cruiser also headed the voyage of both fleets across the North Sea – the voyage which ended in the scuttling of the German fleet at Scapa Flow.

The shipping boom which followed the war added to the wealth of Cardiff's merchant princes. Then came the collapse of the coal trade, a disaster from which Cardiff did not recover until the later twentieth century. As Dai Smith put it: 'In the 1920s, Cardiff was shrinking back into provinciality, and this would be the case until it found a new role as a service capital in the 1960s.' Despite the expansions of 1922 and 1938, the number of Cardiff's inhabitants was only marginally higher in 1939 than it had been in 1921; the helter-skelter population growth of the previous century and more was being stopped in its tracks.

As has already been noted, unemployment among Cardiff's insured adult males reached 36.2 per cent in 1933, less than half the level reached in the worst-hit mining communities. Furthermore, unemployment insurance did not apply to white-collar workers, who were numerous in Cardiff and rare in the coalfield. Most of them remained in employment. Indeed, those on stable incomes saw their standard of living rising in the deflationary 1920s and 1930s. Working-class employment also proved to be more buoyant in Cardiff, partly because the collapse of steel-making at the heads of the valleys led to a concentration of the industry on the coast. Over three million pounds was invested at East Moors, enabling the works to produce half a million tons of steel a year. At the docks, the demands of the steel industry compensated in part for the decline in coal exports; incoming goods came to constitute a quarter of the trade of the port, their increased importance caused almost entirely by the rise in iron-ore imports. The continuing role of steelmaking and of employment at the docks ensured that Cardiff in the 1920s and 1930s was still primarily a working-class community, which explains why all three parliamentary seats granted to the city in 1918 were captured by the Labour Party in 1929.

Despite the greater employment opportunities available in Cardiff, the penury of large sections of the city's working class during the inter-war years should not be minimized. Indeed, the experience of poverty could be more galling in districts where people were aware of the purchasing power of their middle-class neighbours than it was for people in districts where such a class

117

hardly existed. To Glyn Jones, familiar with the poverty of his native Merthyr, there was something more distressing about the adversity of Cardiff's poor. That was at its worst in Butetown, where racial prejudice exacerbated the deprivation caused by the contraction in the employment provided by the docks, but it could be almost as burdensome to the inhabitants of Grange-town, Adamsdown and Splott.

Nevertheless, the inter-war years were not solely a period of depression. The corporation's provision of commodious houses in pleasant surroundings at Ely initiated a revolution in working-class housing. Cardiff proved to be a pioneer in supplying domestic electricity. Low interest rates led to large-scale building of middle-class houses, as the leafy streets of Cyncoed testify. Some of the houses were held under freehold tenure, for the Bute estate began disposing of its urban holdings in 1923. (The surviving Bute leaseholds were sold to the Western Ground Rents Company in 1938.)

Better housing went hand in hand with improved transport facilities. Tramline construction ceased in 1929; trams were progressively phased out and the travelling public became largely reliant upon the corporation's motor buses. (Cardiff's much-loved trolleybuses did not come into operation until 1942; they ceased operation in 1970.) In 1923, the accretion of buildings in front of the castle was demolished, thus providing a handsome vista of its walls. The resultant widening of Duke Street did something to ease congestion in the city centre, but the fact that much of the traffic traversing Glamorgan went through the heart of Cardiff caused increasing difficulties. The construction of a bypass began in 1930 with the laying out of Western Avenue, but forty years would go by before the completion of the scheme. Rail facilites were improved; the Central Station was rebuilt in 1934 using the Portland stone, which was becoming the hallmark of Cardiff's public buildings. However, the great transport excitement of the inter-war years was the aeroplane. Cardiff Municipal Airport was opened in 1930; by the late 1930s, it was handling 26,000 passengers a year, mainly on domestic flights to places such as Torquay and Weston-super-Mare.

Of all the excitements of inter-war Cardiff, the greatest were those provided by the Cardiff City Football Club. Accepted into the Football League in 1920, the team reached the Cup Final in

118

1925, losing 1–0 to Sheffield City. It won the cup in 1927, defeating Arsenal by 1–0. (The victory was somewhat dampened by the fact that Dan Lewis, the Rhondda-born Arsenal goalkeeper, failed to prevent the eminently preventable winning goal.) Hundreds of thousands of people welcomed the team on its return to the city, the crowd even outnumbering that which had lined the streets two years earlier to mourn the death of the world featherweight boxing champion, 'Peerless' Jim Driscoll. The city's rugby team also had its triumphs, including its victory over New Zealand in 1935. However, the chief leisure activity of the inter-war years was provided by the cinema. The city had twenty-one cinemas by 1930, including the luxurious Capitol, completed in 1920.

Cardiff's efforts to underline its role as Wales's chief urban centre continued unabated in the 1920s and 1930s. Work on the National Museum was resumed in 1920 and the first phase of the building was opened in 1927. Designed by the London firm, Smith and Brewer, its restrained outline offers a striking contrast with the flamboyant City Hall. Cardiff took upon itself the duty of providing Wales with its national war memorial, much to the annoyance of Swansea and other Welsh towns. The memorial, described by John Newman as 'a singularly pure and beautiful classical composition', is the centrepiece of Cathays Park and was completed in 1928.

As the twentieth century progressed, most institutions were coming to the conclusion that Cardiff was the only feasible location for the headquarters of their activities in Wales. In 1916, the Roman Catholic Church founded an archdiocese embracing the whole of Wales. It chose Cardiff as the seat of the archbishop, an acknowledgement that Newport, which since 1850 had been the centre of the church's activities in southern Wales, had ceased to be the home of Wales's largest concentration of Roman Catholics. Following the disestablishment of the Church of England in Wales in 1920, Welsh Anglicans founded the Church in Wales, headed by an archbishop elected from among the territorial bishops. Although no archbishop of Wales would reside in Cardiff until the election in 1950 of John Morgan, bishop of Llandaff, the church's administrative offices were located at Cardiff and at nearby Penarth. While the Baptists and Independents remained loyal to Swansea, the

119

Presbyterian Church of Wales established its headquarters at Richmond Road in Cardiff.

More significant in furthering Cardiff's aspirations was the choice of the city as one of the United Kingdom's eight major broadcasting stations, a choice which eventually led to Cardiff becoming a media centre of international importance. As the station was intended to serve south-western England as well as south Wales, it would have been reasonable to have located it in the larger city of Bristol. The choice of Cardiff was yet another example of the city benefiting from the Welsh dimension. (Northern Ireland was to have a station and Scotland was to have two, so Wales had to have one.) It was opened in February 1923 in Castle Street in a building now bearing a commemorative plaque. It moved to Park Place in 1924, where, to quote a BBC official, the neighbouring buildings had 'been converted into offices . . . for professions of the discreeter sort'. After a long struggle, the broadcasting link between Wales and south-western England was broken. In 1937, the Cardiff station received its own wavelength to serve the BBC Welsh Region. The emergence of Cardiff as the headquarters of broadcasting in Wales was much resented at Swansea. The weakness of Swansea as a media centre was underlined in 1932, when its morning daily newspaper, the *Cambria Daily Leader*, ceased publication, causing Wales to have only one such paper. That was Cardiff's *Western Mail*, which had absorbed its rival, the *South Wales Daily News*, in 1928.

The 1930s saw the further strengthening of Cardiff's claims to supremacy in Wales. Although only 37 per cent more populous than Swansea, the number of its retail outlets was 47 per cent larger and the turnover in them was 92 per cent higher. The city became the home of yet another national institution, the Welsh School of Medicine, recognized in 1931 as the fifth constituent college of the University of Wales. Cardiff also acquired the Temple of Peace, a building in the streamlined classical style designed by Percy Thomas. Intended as Wales's shrine to the peace movement, it was completed in 1938, when another world war was imminent.

As has been seen, the Second World War led to a temporary revival in activity at the docks. There were increased employment opportunities elsewhere in the city and its outskirts – at the

Royal Ordnance Factory at Llanishen, for example, and at the vast hospital built at Rhydlafar to treat casualties of the invasion of Normandy. The number of Cardiffians killed in combat – some fifteen hundred – was lower than the four thousand killed in the First World War. However, the Second World War brought a new form of death – the killing of civilians through aerial bombing. While Cardiff did not suffer as greatly as did Swansea, Coventry and London's East End, 355 of the city's inhabitants lost their lives through bombing, 165 of them in the heavy raid of 2 January 1941. Many buildings were severely damaged, among them Llandaff Cathedral, the Cardiff Arms Park stadium and parts of De Burgh Street and Neville Street, Riverside, Croft Street and Rose Street, Plasnewydd, and Jubilee Street, Grangetown.

For Cardiff, the years immediately following the Second World War were not as disastrous as those following the first. Although the tonnage handled at the docks in 1947 was hardly a quarter of that handled in 1920, work at the docks had ceased to be central to the city's prosperity. The East Moors steelworks and engineering firms such as Currans continued to be major employers, but service industries were becoming the basis of the city's economy. The further decline in activity at the docks coincided with the ending of the links between Cardiff and the family which had been responsible for them. In May 1947, John Crichton Stuart inherited the marquessate of Bute from his father, the fourth marquess, who had held the title since 1900. Four months later, the fifth marquess presented Cardiff Castle and its park to the city of Cardiff. On 10 September 1947, the standard of the Bute family was lowered for the last time and, as aeroplanes flew overhead in salute, the marquess expressed his satisfaction in presenting to the city the castle from which it had sprung. The family retained a role in the use of its former property, particularly with regard to the possible selection of a site in the park for a new Roman Catholic Cathedral. Yet that role was vestigial, and the handover in 1947 essentially brought to an end the 181-year association between Glamorgan and the Stuarts of Bute.

Having inherited a significant proportion of the GWR shares received in exchange for the Cardiff Railway Company, the compensation for the nationalization of the coal reserves under

Bute land and the money paid by the Western Ground Rents Company for the family's urban holdings, the fifth marquess was not a poor man. Yet, had he retained and exploited the 175 hectares he made over to the city, he and his descendants would have been wealthy beyond the dreams of avarice. The present marquess – the seventh – the former racing driver Johnnie Dumfries, is reputed to be worth £110 million but, to put his fortune into perspective, it is only a few million pounds more than that owned by the couple who invented the television quiz programme, *Who Wants to be a Millionaire?* In the Cardiff region, 1947 was a remarkable year in the history of aristocratic altruism for, at the same time as the marquess of Bute was giving up Cardiff Castle, the earl of Plymouth gave St Fagan's Castle and its park to the National Museum. (Did landed aristocrats believe that the Labour government elected in 1945 would be more radical – more confiscatory indeed – than it proved to be?)

In its 1945 manifesto, the Labour Party made vague proposals concerning devolution for Wales, although, in reality, it had little interest in the subject. Yet, every devolutionary move – the establishment of the Council of Wales in 1948, for example – served to enhance the role of Cardiff. That was also the case with regard to the nationalization of industries and services, for Cardiff became the headquarters of the Wales Gas Board, the Wales Hospital Board, the South Wales Electricity Board and the Western Region of the National Coal Board. The Conservative government elected in 1951 further added to Cardiff's role, establishing an office there for that Tory innovation, the minister of Welsh Affairs. Then, on 20 December 1955, the minister – appropriately enough, the Welshman, Gwilym Lloyd George – announced in the House of Commons that Cardiff was to be recognized as the capital of Wales. The recognition was in part a reward for Cardiff's support for the Conservative Party. The city was the only major urban centre in Wales with a majority of Conservative councillors and, in the general election of 1955, 50.3 per cent of the vote in Cardiff was cast for Conservative candidates. There were those who argued that capital status was an empty honour, for a country lacking a government of its own offered no role for a capital. Nevertheless, over the following decades, its status as capital would become increasingly central to Cardiff's prosperity and identity.

That status became apparent in 1958 when Wales was host to the Empire Games. Inevitably the country's capital was the venue for most events, among them the swimming competitions held in the newly built, and now sadly demolished, Empire Pool. The athletic competitions were held in the Cardiff Arms Park stadium, rebuilt after the damage it suffered during the war. The stadium had become the sole ground for the matches of the Welsh Rugby Union, which in the mid-1950s was entering the most successeful era in its history. (Significantly, its last match in Swansea was played in 1954, a year before Cardiff was recognized as the capital of Wales.) Growth in awareness of Cardiff as the capital of Wales is partly attributable to the trek from all parts of the country to international matches at Cardiff Arms Park. In 1968, the ground was renamed the Welsh National Stadium and a programme of rebuilding was initiated, which was not completed until 1983.

In 1964, the Labour Party returned to power and fulfilled its pledge to establish a Welsh Office under a secretary of state with cabinet rank. The capital naturally became the seat of the new institution. The most remarkable feature of the Welsh Office's main building, which dominates the northern end of Cathays Park, is the fact that no part of Wales is visible from its chief offices. It consists of a vast addition to the 1938 offices of the Welsh Board of Health and was completed in 1979. By then, other buildings in Cathays Park had been much enlarged, among them the National Museum, the Law Courts, the Glamorgan County Hall and the Welsh College of Advanced Technology. The greatest building activity was that undertaken by the University College. Caröe's ambitious plans were abandoned; the site of his proposed court became a car park and the great hall which was to close the court was replaced by a line of railings. North of the original college, a series of multi-storey buildings was erected, wholly out of scale with the rest of Cathays Park. As a result, the subtlety of the original concept of the park has been lost, for that depended as much upon the spaces between the buildings as upon the buildings themselves.

The establishment of the Welsh Office coincided with the appointment of the urban traffic experts, Colin Buchanan and Partners, as consultants to the Cardiff Corporation. After a four-year study, they proposed in 1968 the building of a six-lane

The former Welsh Office, now the Executive Office of the National Assembly for Wales. The front building, completed in 1938, was originally the head-quarters of the Welsh Board of Health. Behind it is a massive rectangle designed by Alex Gordon and Partners and built between 1972 and 1979. It was described by the Architects' Journal *as 'a symbol of closed inaccessible government', conveying an impression of 'bureaucracy under siege'.*

highway which would gash its way through Roath, Adamsdown and Plasnewydd and then sweep through a widened Queen Street and on to Duke Street and Castle Street, devouring the Animal Wall on its way. The scheme involved the demolition of seventeen hundred properties and was greeted with uproar. The debate dragged on for years, spreading planning blight over wide areas. It was eventually abandoned because of financial problems and the decline in the Conservative vote. Instead, the corporation opted for radically different schemes – the pedestrianization of much of central Cardiff and the completion of an inner ring road. Now, Queen Street and the area around St John's Church resound to the sound of walking feet and the music of buskers, and the city's heart can be enjoyed without the threat of being run over or being asphyxiated by traffic fumes. The inner ring road was completed in the 1970s when Eastern Avenue was linked to the M4 at St Mellons, obliterating William Burges's Convent of the Good Shepherd at Pen-y-lan on the way. The completion of the Cardiff section of the M4 and its approach roads both relieved and exacerbated the city's traffic problems. Traffic traversing Glamorgan has ceased to impinge upon Cardiff, but the approach roads have proved to be effective funnellers of vehicles into the city. One approach road, the A4232, defines Cardiff's western boundary, and the whole

motorway complex has been central to the city's increasing prosperity.

Cardiff's western boundary was defined in 1974, the year in which the city ceased to be a unitary authority. Local government reorganization had long been discussed. For Glamorgan, the favoured option was the division of the county into eastern and western sections with their administrative centres at Cardiff and Swansea. However, there were those who thought that a capital city should have special status; furthermore, the Conservatives had no wish to see Cardiff merged with the rest of east Glamorgan in a unit they would have no hope of dominating. The final decision involved the division of east Glamorgan into the impoverished Mid Glamorgan of the coalfield and the prosperous South Glamorgan centred upon Cardiff. Within the new county, Cardiff became a district authority alongside that of the Vale of Glamorgan, an arrangement which came to be seen as a gross example of too many layers of local government. In the reorganization of 1996, when Wales's eight counties were transformed into twenty-two unitary authorities, Cardiff again became a county borough.

Five years after the creation of South Glamorgan, its inhabitants had an opportunity to vote on a proposal which, had it been implemented, would have had a significant impact upon Cardiff. The proposal was the establishment of a National Assembly for Wales which would meet in the Coal Exchange in Butetown. The voters of South Glamorgan rejected the Assembly by 144,186 votes to 21,830. Cardiff's massive rejection of an opportunity to become a more meaningful capital raised questions about the way Cardiffians viewed themselves in relation to the rest of Wales. Clearly, notions that Welsh nationality had political implications were viewed more negatively in Cardiff than were parallel notions in Lothian, the county which included Edinburgh; there, a majority – admittedly a small one – voted in favour of a National Assembly for Scotland. Although pride in being the Welsh capital was a widely held sentiment in Cardiff, few Cardiffians had more than a nodding acquaintance with most of the rest of Wales. Furthermore, there was much suspicion of the ultimate aims of the advocates of devolution, who were often considered to be aiming at independence for Wales and/ or at the dominance of Welsh-speakers at the expense of the

125

overwhelming majority in Cardiff who had English as their mother tongue.

Of the city's MPs (the number had been increased to four in 1974), two belonged to the strongly anti-devolutionist Conservative Party. Of the two Labour MPs, George Thomas was bitterly opposed to any advance in the recognition of Welsh nationality, and James Callaghan, the prime minister, gave only lukewarm support to what was his own government's policy. The collapse of the Callaghan government's devolution plans led to a general election and to the victory of Margaret Thatcher. Eighteen years of Conservative rule led many to view devolution for Wales in a more kindly light. When a further referendum on a National Assembly was held in 1997, the positive vote in Cardiff was 44 per cent compared with the 13 per cent in south Glamorgan in 1979.

Unlike the proposal of 1979, there was in 1997 no pre-referendum decision concerning the Assembly's location. Swansea argued that, as 52 per cent of those voting in that county borough had voted yes, the city should be chosen as the location. (However, Swansea's positive vote was undoubtedly strongest in the county's northern areas; indeed, it is probable that, in the city itself, support for the Assembly was lower than it was in Cardiff.) After yet another acrimonious debate between Swansea and Cardiff, and much discussion of the merits of Cardiff's City Hall, a decision in favour of Butetown was made. The Assembly was opened in Crickhowell House by the Queen on 26 May 1999, and its location was seen as another factor aiding the success of the plans for Cardiff Bay.

Cardiff's Welsh-speakers, viewed as such a threat in 1979, had by then long been only a small minority of the city's inhabitants. As has been seen, Cardiff may well have had a Welsh-speaking majority in the 1830s. A hundred years later, the proportion had declined to 5 per cent and, of those claiming to speak Welsh, 50 per cent were over fifty years of age. The fact that less than 10 per cent of Cardiff's Welsh-speakers were under fifteen was a matter of grave concern to the devotees of the language, who, in the immediate post-war years, were determined to establish a Welsh-medium primary school in the city. It opened with nineteen pupils in 1949, and ushered in what has been called 'a quiet revolution'. By 1998, 1,925 primary school pupils were attending the city's

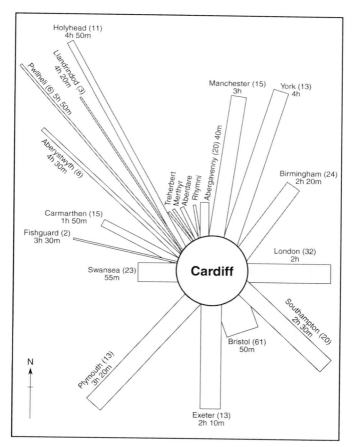

A chart showing train journeys from Cardiff. The figures refer to the number of trains per working day and the length of the journey. It illustrates the paucity of links between Cardiff and most of the rest of Wales, and the abundance of links between the city and the major urban centres of England. It also illustrates the inordinate length of many of the journeys within Wales. Thus, the journey to Pwllheli, which is two hundred kilometres from Cardiff, takes almost six hours; the equivalent figures for York are three hundred kilometres and four hours. A chart of long-distance bus journeys would illustrate the issue in an even more extreme form.

nine Welsh schools and a further four such schools were soon to open. In addition, there was a Welsh-medium secondary school in Llandaff North and others were being planned. Cardiff had 2,190 Welsh-speakers under the age of fifteen in 1971 and 5,208 in 1991, when the proportion in that age group able to speak the language was 153 per cent higher than it was in the age group over sixty-five. Overall, the number of Cardiff's Welsh-speakers increased from 9,623 in 1951 to 17,236 in 1991, and the figure for 2001 will undoubtedly be considerably higher. There were similar developments in Cardiff's immediate hinterland: in 1991, 10 per cent of the Welsh-speakers of Wales lived within twenty-five kilometres of Cardiff, compared with 5 per cent forty years earlier.

Initially, Cardiff's Welsh-medium schools attracted pupils whose parents worked in education, administration and the media, and were therefore recruited in the main from the prosperous parts of the city. This is reflected in the fact that in 1991 Welsh-speakers constituted nearly 12 per cent of the inhabitants of Radyr and Rhiwbina, more than three times the proportion in Cardiff's poorer districts. However, with the establishment of Welsh-medium schools in places such as Grangetown and Llanrumney, the class balance within Cardiff's Welsh-speaking community is likely to change. As there are no localities within the city where Welsh-speakers are as high as one in five of the inhabitants, there are doubts whether so scattered a linguistic community can create the social networks necessary for language maintenance. Yet, with several areas of the city having more than 350 Welsh-speakers per square kilometre, there may be enough of them in close proximity to each other to permit such networks to be created. Nevertheless, perhaps the soundest comment on the Welsh language in Cardiff is that of John Aitchison: 'Welsh is a plant which has been growing energetically but which has not as yet produced a deep and extensive root system.'

There were areas apart from schooling in which Cardiff's Welsh-speakers were active. The movement to establish Welsh community newspapers, *papurau bro*, began in Cardiff, where the monthly *Y Dinesydd* (The Citizen) has been published since 1973. Some leading Welsh-language writers – Harri Pritchard Jones, Siôn Eirian and Wiliam Owen Roberts among them – live there, and the city is the background of much of their work. The employment opportunities provided by Welsh-medium schools

and the production of Welsh-language television programmes have attracted significant numbers of young Welsh-speakers to Cardiff, which in large areas of Wales is now viewed as the preferred place to live and work. The dominant form of the language spoken by them is that of west Wales for, within the city, the dialect of south-east Wales is now only spoken by a handful of people around Pentyrch. Yet, although the vowel forms of south-eastern Welsh are virtually extinct in Cardiff, they do survive in the city's English-language dialect. The speech beloved of the Kairdiff Langwidge Sitey, with phrases such as 'a pint of dêk in Kêdiff Êms Pêk', reflects the narrow *e* which was once a characteristic of the Welsh spoken over a wide swathe of eastern Wales.

Cardiffians have been prominent as activists in campaigns to seek official status for Welsh; indeed, the first protest of Cymdeithas yr Iaith Gymraeg (the Welsh Language Society) was planned in Cornwall Street, Grangetown. The success of the activists is immediately apparent. When Cardiff was recognized as Wales's capital, Welsh was virtually invisible in the city but,

An example of the bilingual signs which are now a feature of most parts of Cardiff.

129

now, no visitor to the city can be unaware of the language. Yet, Cardiff has a long way to go to achieve the bilingualism of Ottawa, the capital of a country where the proportion of French-speakers (23 per cent) is not much higher than the proportion of Welsh-speakers in Wales (18.6 per cent).

An exploration of the twentieth-century city should start where it was recommended that a search for the origins of Cardiff should begin – at the castle. There, explorers should walk past the Animal Wall, completed in its present position in 1931, and ignore the many banners on the castle walls announcing that Cardiff is Europe's youngest capital. (Vitoria-Gasteiz won recognition as the capital of the Basque Country as recently as 1979.) From the castle, it is a mere step to pay one's respects to Aneurin Bevan, whose statue's defiant stance threatens to topple him into the street. Cathays Park beckons, and reaching it involves passing the unappealing buildings of the Bank of Wales, a monument to the failed attempt to make Cardiff a financial centre which could vie with Edinburgh. (The bank is now owned by the Bank of Scotland.)

Cathays Park has a number of sculptures, including a statue of Lloyd George who seems to be shaking his fist at the National Museum. Behind him is Gorsedd Gardens, where the stone circle is a reminder that the National Eisteddfod has been held five times at Cardiff – in 1883, 1899, 1938, 1960 and 1978. Days could be profitably spent in the National Museum, and visitors should also wander around the City Hall which, since the abolition of the Cardiff District Council in 1996, is a building looking for a function. A walk through Cathays Park will convince explorers of its now too cluttered character and of the aesthetic loss resulting from the abandonment of respect for the cornice line of the City Hall. Many of the park's buildings are now owned by the University College which amalgamated with the University of Wales Institute of Science and Technology in 1988, partly in order to avoid bankruptcy. Thus, the University College acquired the buildings of the original technical college of 1916 and the Redwood Building of 1961 – both the work of the firm of Percy Thomas. A further major acquisition occurred in the late 1990s, when the University College took over the complex previously occupied by the defunct Mid Glamorgan County Council. Across the road from that complex lies the

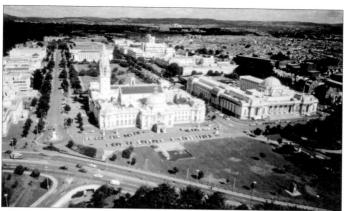

Cardiff's Civic Centre, with the City Hall in the centre, flanked on the left by the Law Courts and on the right by the National Museum.

Welsh College of Music and Drama, with its Bute Theatre (1977). At the top of Cathays Park is the fortress-like Welsh Office, renamed in 1999 the Executive Office of the National Assembly. It is worth going beyond that fortress to look at Cardiff's most sought-after housing estate, the neo-Georgian houses in Queen Anne Square. Casual visitors are not encouraged there, but even mere mortals may peep through the square's dainty protective screen.

It is worth returning to the city's commercial centre to enjoy the bustle of the pedestrianized Queen Street and to wander through the well-designed St David's Shopping Centre, occupied by the kind of shops which can be seen anywhere. In the Centre, the statue of the rugby player, Gareth Edwards, should be looked at; his is Cardiff's only statue, apart from that to John Cory, where the person depicted was still alive at the time of installation. Beyond Queen Street lies Charles Street, where St David's Metropolitan Cathedral disappoints those who feel that Wales's chief Roman Catholic church should be rather grander. The houses of Charles Street were once occupied by Cardiff's mercantile elite; the street is now the centre of the city's small but lively gay scene. Beyond Charles Street are a number of modern hotels, a flamboyant cinema complex, the Cardiff International

131

Arena and the World Trade Centre. Adjoining is the Welsh National Ice Rink; since the 1990s, it has been the home of the Cardiff Devils, a team which has rapidly won fame among followers of ice hockey. The surrounding area contains several buildings used by the Welsh National Opera Company. Founded in 1946, it is the sole world-renowned opera company whose only premises are a series of warehouses.

Across the railway line lies Bute Square which, with its fine stained-glass fountains and its statue of the second marquess of Bute, is intended to be a new and important focal point of the city. From it, sightseers should go back beneath the railway line to the Hayes, there to visit St David's Hall, completed in 1982 as the 2,000-seat national concert hall of Wales. It is the home of the hugely popular Cardiff Singer of the World Competition, the launching pad for the remarkable career of Bryn Terfel. From the Hayes, Mill Lane – Cardiff's rather self-consciously bohemian café quarter – takes the explorer to St Mary's Street and on to the site of what was Wales's largest place of worship – the 3,000-seat Wood Street Congregational Chapel, demolished in 1973 to permit the erection of uninspiring offices and the Central Bus Station. From there, it is worth wandering through the narrow lanes behind St Mary's Street, once crammed with early nineteenth-century houses. Such houses survive in Jones Court and, in a prize-winning scheme, they were converted into luxurious offices in 1985.

Jones Court gives access to Westgate Street, the location of contemporary Cardiff's greatest wonder, the Millennium Stadium, completed for the Rugby World Cup Competition of 1999. It is breathtaking and is likely to become as much a symbol of Cardiff as is the Eiffel Tower of Paris and the Opera House of Sydney. 'Wow', gasp visitors coming out of the Central Station, 'a space ship has landed.' Sit within it, dear explorer, and come to the conclusion that, if Cardiffians can achieve this, they can achieve anything. Or, as I would like to state – assuming that such a comment by a Rhondda-born, Ceredigion-bred intermittent resident is permissible – if we Cardiffians can achieve this, we can achieve anything.

Further Reading

Those seeking a full list of publications should consult B. Ll. James, *Bibliography of the History of Cardiff* (Cardiff, 1989).

The publications listed here are those which have been extensively used in this study or which have been quoted in it.

Aitchison, J., 'The Welsh language in Cardiff, a quiet revolution', *Transactions of the Institute of British Geographers*, new series, XII (1987).

Carter, H., *The Towns of Wales* (Cardiff, 1965).

Chappell, E. L., *History of the Port of Cardiff* (Cardiff, 1940).

Crook, J. M., *William Burges and the High Victorian Dream* (London, 1981).

Daunton, M. J., *Coal Metropolis: Cardiff, 1870–1914* (Leicester, 1977).

Davies, J., 'Aristocratic town-makers and the coal metropolis', in D. Cannadine (ed.), *Patricians, Power and Politics in Nineteenth-century Towns* (Leicester, 1982).

Davies, J., *Cardiff and the Marquesses of Bute* (Cardiff, 1981).

Edwards, E. W., 'Cardiff becomes a city', *Morgannwg*, IX (1965).

Evans, C., S. Dodsworth and J. Barnett, *Below the Bridge* (Cardiff, 1984).

Evans, N., 'The south Wales race riots of 1919', *Llafur*, III, I (1980).

Evans, N., 'The Welsh Victorian city: the middle class and civic and national consciousness in Cardiff, 1850–1914', *Welsh History Review*, XII, 3 (1985).

Glamorgan County History, 6 vols (Cardiff, 1936, 1971, 1974, 1980, 1984, 1988).

Henriques, U., 'The Jewish community of Cardiff, 1813–1914', *Welsh History Review*, XIV, 2 (1988).

Jenkins, P., 'The Tory tradition in eighteenth century Cardiff', *Welsh History Review*, XII, 2 (1984).

Jenkins, R. T., *Edrych yn Ôl* (London, 1968).

Jones, G. and M. Quinn, *Fountains of Praise: University College, Cardiff, 1883–1983* (Cardiff, 1983).

Jones, Jack, *River out of Eden* (London, 1951).

Lloyd, G., *C'mon City: A Hundred Years of the Bluebirds* (Bridgend, 1990).

McLees, D., *Castell Coch* (Cardiff, 1998).

Matthews, J. H. (ed.), *Cardiff Records, Materials for the History of the City*, 6 vols. (Cardiff, 1898–1911).

Morgan, D., *The Cardiff Story* (Cowbridge, 1991).

Morgan, R., *Cardiff: Half-and-Half a Capital* (Llandysul, 1994).

Newman, J., *The Buildings of Wales: Glamorgan* (London, 1995).

Rammell, T. W., *Report on . . . the Sanitary Condition of the Town of Cardiff* (London, 1850).

Rees, W., *Cardiff: A History of the City* (Cardiff, 1969).

Roderick, G. W., 'A new college for south Wales: Cardiff versus Swansea', *Transactions of the Honourable Society of Cymmrodorion*, new series, VI (2000).

Sinclair, M. C. N., *The Tiger Bay Story* (Cardiff, 1993).

Thomas, H. M. (ed.), *The Diaries of John Bird of Cardiff* (Cardiff, 1987).

Walker, D., 'Cardiff', in R. Griffiths (ed.), *Boroughs of Medieval Wales* (Cardiff, 1978).

William, E., *Museum of Welsh Life: Visitor Guide* (Cardiff, 2000).

Williams, G. J., *Iolo Morganwg* (Cardiff, 1956).

Williams, G. A., *The Merthyr Riots* (London, 1978).

Index

138

Petersen, David 96
Pierhead Building 72–3
Plasnewydd 44, 45, 82, 88–91, 121, 124
Plasturton Gardens 94, 95
Plymouth Arms 111
Pontcanna 46, 92–3, 94, 95, 96
Pontcanna Fields 2, 93
Pontprennau 109
population 16, 19, 27–8, 30, 35, 36, 37, 46–9, 51, 65, 69, 75–6, 102, 117, 120
Presbyterian Church of Wales 119–20
Prichard, John 88, 96, 99, 101
Probate Registry (Llandaff) 99
Protestantism 30, 40, 42
Puritanism 30–1
Pwllheli 127

Quakerism 31
Queen Anne Square 131
Queen Street 16, 34, 82, 114, 115, 124, 131

race riots 75–6, 103
Radyr 25, 65, 110, 128
Rammell, T. W. 42, 43
Rat Island 73
Reardon Smith Shipping Company 79
Redwood, John 109
Redwood Building 130
Rees, William 89
Reformation, the 22–4
Report on the Sanitary Condition of the Town of Cardiff (1850) 42, 43
Rhiwbina 107–8, 110, 128
Rhondda Valley 5, 40, 59, 119
Rhymni (river) 1, 82, 106, 109
Rhymni Railway 5, 7, 76
Rhymni Valley 5–7, 59
Richards, E. P. (agent to Bute estate) 35–7, 42, 46, 89
Richards family (Plasnewydd) 44, 45, 89
Rickards, E. A. 113
Riverside 46, 79, 92–6, 121

Roath 25, 47, 48, 82, 87–9, 91, 124
Roath Brook 2, 45–6, 89
Roath Court 44, 45, 89
Roath Park and Lake 2, 89, 105
Robert, earl of Gloucester 11, 14
Robert, duke of Normandy 14
Rogers, Richard 81
Romans, the 11, 13, 14, 103
Rookwood 99
Royal Arcade 52
Royal Hamadryad Hospital 55, 73
Royal Hotel 52
Royal Infirmary 84, 110
Rubens, Bernice 88
Rugby World Cup (1999) 132
Rumney 2, 105, 106, 108

St Augustine's Church 106
St David's Centre 16, 131
St David's Church (Fairwater) 103
St David's Hall 132
St David's Hospital 93–4
St David's Hotel 80
St David's Metropolitan Cathedral 131
St Denys's Church 109
St Fagans 14, 44, 45, 110–11
 battle of 31
 castle 110, 122
 church 111
St German's Church 85
St John's Church 1–2, 19, 21–2, 23, 28, 37, 43, 106, 124
St John's Church (Canton) 96
St John's (parish) 28, 30, 33, 43, 46–8, 82, 91
St Margaret's Church 88–9
St Mary's Church 19, 28, 58
St Mary's (parish) 28, 30, 33, 43, 46–8, 55, 82
St Mary's Street 18, 32, 37, 38, 44, 49, 52, 114, 115, 132
St Mellons 2, 105, 106, 108, 109, 124
St Nicholas's Chapel 19, 22
St Peter's Church 90
St Piran's Chapel 19, 22
Santayana, George 58

140

141

142